Tanika Gupta

MEET THE MUKHERJEES

OBERON BOOKS
LONDON

First published in 2008 by Oberon Books Ltd
521 Caledonian Road, London N7 9RH
Tel: 020 7607 3637 / Fax: 020 7607 3629
e-mail: info@oberonbooks.com
www.oberonbooks.com

A catalogue record for this book is available from the British
Library.

ISBN: 978-1-84002-861-4

Printed in Great Britain by CPI Antony Rowe, Chippenham.

MEET THE MUKHERJEES

Characters

CHITRA
50-year-old Asian woman. Anita's mum.

NEVILLE
60-year-old Afro-Caribbean man. Aaron's dad.

ANITA
31-year-old Asian woman.

FRAN
30-year-old woman. Anita's best friend.

AARON
32-year-old Afro-Caribbean man.

LETICIA (LETTY)
Afro-Caribbean woman in her fifties.
Aaron's mum

MONTU
Asian man in his fifties. Anita's father.

INDIA
13-year-old mixed race girl. Aaron's daughter.

RAJ
Montu's brother.

MONTU and RAJ can double up.

Meet the Mukherjees was first performed at the Bolton Octagon on 1 May 2008, with the following cast:

CHITRA, Pooja Ghai

NEVILLE, Wyllie Longmore

ANITA, Rokhsaneh Ghawam-Shahidi

FRAN, Keeley Forsyth

AARON, Mark Springer

LETICIA, Anni Domingo

MONTU / RAJ, Nicholas Khan

INDIA, Ayesha Gwilt

Director Mark Babych

Act One

SCENE 1

We are outside. CHITRA MUKHERJEE, a Sari-clad Asian woman in her late forties sits on a sunny bench in a city park and eats a sandwich with one hand and busily texts on her mobile phone with the other. We hear bird song. NEVILLE, an Afro-Caribbean man in his late fifties enters. He is dressed in the uniform of a Manchester bus driver. He looks pleased to see CHITRA.

NEVILLE: (*Jamaican accent.*) Pleasant day.

CHITRA: (*Indian accent.*) Very mild.

> *NEVILLE sits down on the park bench but makes sure there is plenty of space between them. CHITRA continues to text and doesn't look up. NEVILLE takes out his packed lunch.*

NEVILLE: Me not see you all week Mrs Mukherjee.

CHITRA: I've been unwell Mr Jackson.

NEVILLE: Oh? Anyt'ing serious?

CHITRA: It's silly really.

NEVILLE: 'Ooman trouble?

CHITRA: No!

NEVILLE: What den?

CHITRA: It's private.

> *NEVILLE nods and eats his patty in respectful silence. CHITRA waits for NEVILLE to show some interest. She looks put out.*

How was your shift?

NEVILLE: Long. Watching de clock. Me start at five o'clock dis morning.

7

CHITRA: Would have thought you were used to it by now.

NEVILLE: Yeah mon but today was a nightmare. Bus broke down half way down Oxford Road right in the middle of de road in the rush hour. Had to trow all me passengers off. Got some nasty curses.

CHITRA: Bus broke down?

NEVILLE: Black smoke billowing from the engine. People start screamin' – tink it a terrorist attack.

NEVILLE chuckles to himself and produces some patties which he eats.

CHITRA: You shouldn't joke about the terrorists. Place is crawling with extremists. You mark my words, one day it will happen, right here, right in the city centre. It happened once before – remember?

NEVILLE: Different terrorists.

CHITRA: They're all fanatics.

NEVILLE: Gyal, you sound like my wife.

CHITRA: She sounds like a woman with good sense.

NEVILLE: Me spend a whole hour waitin' for de garage to send someone, den it take another hour waitin' for a tow truck. Me lickle bus cause total Manchester gridlock.

CHITRA: You must have been popular.

Beat.

NEVILLE: So you not been well?

CHITRA can't contain herself any longer.

CHITRA: Well, if you must know, I've been having these panic attacks.

NEVILLE: Hmmm…

CHITRA: Terrible… I can't breathe, I think I'm going to explode…tightness in my chest…feeling of terror…gasping for breath…

NEVILLE: Sound bad.

CHITRA: You ever experienced a panic attack?

NEVILLE: Yeah mon, for years…everytime me see me mudder in law.

NEVILLE laughs at his own joke. CHITRA tries to look annoyed but can't help being amused.

CHITRA: This is serious Mr Jackson!

NEVILLE: So was mine! You haven't met my mudder in law. Make Mohammed Ali look like a featherweight. She never like me. So, you havin' dese panic attacks a lot?

CHITRA: Used to be once in a while. You know, lifts, closed in areas… I was always a little claustrophobic as a child. Now…it's happening in the kitchen, in the bathroom, in my work place…everywhere.

NEVILLE: You should go an' see a doctor – you work in dat surgery – must be easy to get an appointment.

CHITRA: I already have.

NEVILLE: What the doctor him say?

CHITRA: Asked me a lot of stupid questions. Said I was over anxious.

NEVILLE: You worry too much.

CHITRA: That's what he said but I have a lot to worry about.

NEVILLE: Woman dem always worry 'bout nutten.

CHITRA gives NEVILLE a hurt look.

NEVILLE offers a patty as a peace offering. CHITRA waves it away.

NEVILLE: So why you worry?

CHITRA: My daughter.

NEVILLE: Ahhh…

CHITRA: She calls me old-fashioned. She says I am stuck in the middle ages, that I should be put in a museum so that everyone can come and see a relic!

NEVILLE: How she is?

CHITRA: She'll be thirty – next week.

NEVILLE: No, me mean how she doing?

CHITRA: Doing? Doing? She's not doing anything.

NEVILLE: She not working?

CHITRA: Of course she works, huge law firm in town– she's a solicitor, a senior partner – but she completely refuses to settle down.

NEVILLE: She young.

CHITRA: She should marry! Give me some grandchildren before she's too old.

NEVILLE: Thirty – is still young.

CHITRA: After thirty, a woman's body…babies…

NEVILLE: Hmmm…

CHITRA: I've tried to talk to her, but she never listens to me. If only Montu was still here. He'd talk some sense into her.

NEVILLE: My son…around the same age…always prowling around…his mudder and me are fed up of meeting his

girlfriends. In the end though, dem children have to make dem own decision.

CHITRA: But they make the wrong decisions Mr Jackson!

NEVILLE: Sometime. True.

CHITRA: It makes me feel – useless, helpless. But I can't just sit back. There's too much to lose. Back home, she would have been married off by now.

NEVILLE: Back home…

CHITRA: Is there something wrong with my daughter?

NEVILLE: Come now…

CHITRA: Maybe she's ugly…

NEVILLE: All o'dem Indian gyal dem look pretty to me. Dark hair, dark eye dem, sweet faces, curves…

CHITRA smiles coyly.

CHITRA: She doesn't even have any boyfriends, least not any that I've met.

NEVILLE: You is not so backward that you wouldn't welcome a young man into your home eh?

CHITRA: (*Pleased that NEVILLE understands her.*) Exactly! As long as he was from a good family…

NEVILLE: I tink…

CHITRA: And then I worry that maybe, just maybe she…you know…you know… (*Conspiratorially.*) perhaps, she's GTG.

NEVILLE: GTG?

CHITRA: 'Got the gay'.

NEVILLE: (*Laughs in agreement.*) Ha! White man disease.

CHITRA: It *is* a disease! She lives with this girl – Fran – nice girl but there's something funny about her. She has very short hair.

NEVILLE: Hmmm…

NEVILLE shakes his head as if to say CHITRA is over-reacting.

CHITRA: What would the family say? What would my poor late husband say? If she was…if she turned out to be…*hai Ram*. Back home, they would parade her round the village and beat her with sticks.

NEVILLE: Not every ting dem do back home is good Mrs Mukherjee.

Beat.

I will be turning sixty next month.

CHITRA: You don't look a day over 45.

NEVILLE: Tanks but you is a liad.

They both laugh.

CHITRA: I forgot we share the same birthday.

NEVILLE: Yes, the stubborn Taurus bull, so my wife keeps telling me.

CHITRA: My husband used to call me – 'obstinate'.

NEVILLE: But we de anchor of society Mrs Mukerjee.

CHITRA: Absolutely. 'The axle of the heavens' an astrologer once told me. Without our stability and so-called stubbornness, the wheels of the world would not turn.

NEVILLE: I must remember dat.

CHITRA's phone rings.

CHITRA: Excuse me Mr Jackson.

CHITRA takes the call.

Hullo…hullo?…Who is this?

CHITRA holds on for a minute and then hangs up. She looks at her phone perplexed.

I keep getting these calls…when I pick up, I just get this crackly line…ten of them just this week!

NEVILLE: Maybe it a secret admirer.

CHITRA: I don't know who it is. It keeps saying UNKNOWN.

CHITRA looks at her phone again.

So Mr Jackson. How do I talk sense into my daughter?

NEVILLE: You askin' me?

CHITRA: Yes!

NEVILLE: You want the truth now?

CHITRA: Your honest opinion.

NEVILLE: Take it easy.

CHITRA: That's it?

NEVILLE: Stop worryin' an' your panic attack dem disappear.

CHITRA: And what about the fact – the fact that my daughter may never marry?

NEVILLE: She have her health and she have a good job. Marriage come when she ready for it. It her life not yours.

CHITRA thinks for a while.

CHITRA: I have to get back to work.

NEVILLE stretches and yawns.

NEVILLE: And I go back to me bed.

SCENE 2

ANITA and FRAN are in a bar after work.

FRAN: He called you?

ANITA: Just like that. Out of the blue. Haven't heard from Kiren for six months.

FRAN: He's got a nerve. What did he say?

ANITA: That he realises that he loves me and he can't live without me.

FRAN looks upset.

FRAN: And…?

ANITA: What?

FRAN: How d'you feel about it?

Beat.

ANITA: It's the first time he ever told me he loved me.

FRAN groans.

Made me want to cry.

FRAN shakes her head.

ANITA: Went straight back into that place – y'know – needy, desperate, yearning…

FRAN: Anita…

ANITA: Kiren always had that effect on me.

FRAN: He treated you like shit.

ANITA: Fran, I'm not about to let him back in…it was just…a shock – hearing from him again.

FRAN: What did he want?

ANITA: He's broke. Needs a loan.

FRAN: So he heard about you becoming a partner in the law firm?

ANITA: Must have.

FRAN: User.

ANITA: I told him to sod off.

FRAN: That's my girl.

ANITA: I don't need him.

FRAN: You don't. He's a…little boy. You're a woman. And you need a man.

ANITA: If he'd called me just a month ago…maybe…

FRAN: DON'T.

ANITA: But I've let go of him. Had enough of his games. Thing that made me laugh was he was doing what he used to do…pretending that I needed his manly protection…

FRAN: He's the one that needs protection.

Beat.

ANITA: It's a friggin' desert out there Fran. What happened to all the fit men?

FRAN: Must be hanging somewhere else tonight.

ANITA: Not round here that's for sure.

FRAN: Mind you, it'd help if you'd get some decent gaydar installed into your system.

ANITA: What?

FRAN: When are you going to stop chatting up fruits?

ANITA: *They're* the ones that chat *me* up. Always the best looking by far.

FRAN: Sod's law…such a waste.

ANITA: How the hell am I supposed to know they're just being friendly?

FRAN: If you can't work it out, first thing you should ask in future is 'are you into musical theatre'? If they start singing every song from *Oklahoma!* to *Billy Elliot* – you'll know for sure.

ANITA: Problem is there are no more fit single straight men left in the world.

FRAN: Problem is, we're getting to the age where they're either married, taken or just too weird which is why they're still single.

ANITA: You saying we're past it?

FRAN: No! Get lost. Just saying…our options are shrinking.

ANITA: And our assets are sagging.

They both laugh.

I don't think I'll ever fall in love again – not like I did with Kiren.

FRAN: Love – babes – makes the world go around. That's what they say anyway.

ANITA: It's a disease. You can't eat, can't sleep, all you do is think about them obsessively and then when they don't call or text, you sit there worrying, agonising, torturing yourself.

FRAN: I'd like to fall in love.

ANITA: Fat chance.

FRAN: What you saying? I can be fucking romantic!

ANITA: Yeah right.

FRAN: We could go for a divorcée. Plenty of those around.

ANITA is silent.

What about internet or speed dating?

ANITA: Saddo.

FRAN: There's always the arranged marriage thing.

ANITA glares at FRAN.

Your mum'd be made up. Think she could find me one too?

ANITA: Now you sound totally bloody desperate.

FRAN: I am! Haven't had a shag in…

ANITA: A week.

FRAN: More than that.

ANITA: What about that Graham bloke you copped off with? In Canal street…? He was hot! *And* you went back to his place.

FRAN: He was all wandering hands and broken promises. And…

FRAN waggles her little finger suggestively.

ANITA: No? But he had a six pack, he looked like he had something.

FRAN: Needed a fucking microscope. It was like trying to fuck a peanut.

ANITA cracks up.

Nah – there's no other option. Gonna have to have a word with your mum.

ANITA: You trust my mum's taste in men?

FRAN: She chose your dad. He was lovely your dad was.

ANITA: She got lucky. Anyway, it's called 'arranged marriage' so that they can 'arrange a marriage' – not arrange hot sex for a week.

FRAN: Can't you try them out? You know like, give them a road test? See if they pass the bedroom MOT? Then if they're no good in the sack, you move on to the next one...

ANITA: Doesn't work that way Fran. It's all about houses, cars, good jobs, viable career prospects, nice families, good genes.

FRAN: Boring.

ANITA: To have and to hold, 'til death us do part. And then there's kids.

ANITA and FRAN both look wistful but don't say anything.

FRAN: Maybe we're better off without blokes.

ANITA: Yeah.

FRAN: All this desperate searching for a soul mate...

ANITA: We got each other.

FRAN: Exactly.

SCENE 3

It is late at night. AARON is sat at a table wolfing down a plate of food. LETICIA enters bleary-eyed in her dressing gown.

LETICIA: And what kind of a time is this to be eating your dinner?

AARON: Delicious mum.

LETICIA: You even heat that food up?

AARON: Yeah. I'm not that bad.

LETICIA sits and watches her son eating.

LETICIA: Where've you been?

AARON: Club.

LETICIA: They don't feed you there?

AARON: No. Not in clubs mum. It's strictly dancin'.

LETICIA: And drinking.

AARON: Yeah – and that.

LETICIA: You go with Saffron?

AARON: Nah. I was with my boys.

LETICIA: Wha' happen to Saffron?

AARON shrugs.

Lord have Mercy – you let go of her arready?

AARON: Yep.

LETICIA: How long she last? Three months?

AARON: Mum…

LETICIA: You gonna get yourself a reputation. No good
'ooman gonna wan' anyting to do wid you.

AARON: She wanted a boyfriend with a fast car and loads of
dosh.

LETICIA: Look at your sistah – younger than you and her all
settled, nice house, nice family. What you doin' with your
life?

AARON: It's three in the mornin'. Can't we do this some other
time?

LETICIA sucks her teeth.

LETICIA: I wish to God you'd grow up and take up some responsibilities. Treat this place like a hotel.

LETICIA gets up and leaves the kitchen. AARON continues eating. He doesn't seem to be in the least bit bothered. NEVILLE wanders in, bleary-eyed. He stops when he sees AARON.

AARON: Alright dad?

NEVILLE looks at his watch. He pours himself a drink of milk from the fridge.

Having problems sleeping?

NEVILLE: Your mudder. Wake me up wid her cursin'.

AARON: She was having a go at me.

NEVILLE joins AARON at the table. He drinks his milk thoughtfully.

NEVILLE: She worry for you.

AARON: I should move out.

NEVILLE: She still worry for you.

AARON: Gettin' a bit old for this. Still being told off when I come in late. I'm not a teenager.

NEVILLE: Why you behave like one then?

AARON: Not you as well.

NEVILLE: At your age, I have two kids, a job, a wife and rent to pay. Worse luck.

AARON: I've got a job.

NEVILLE: You have?

AARON: That's why I went out. To celebrate.

NEVILLE: (*Amazed.*) It a good job?

AARON: Yeah. Photographer for the *Evening News*. Start work on Monday.

NEVILLE: Permanent?

AARON: Six-month contract. Obviously, if we both get on then they'll extend it for another six months.

NEVILLE: Then we should celebrate. My son has a job!

NEVILLE crashes around in the cupboards.

Rass…That 'ooman – always hiding my…

AARON: If you're looking for the Appleton, it's in the bottom cupboard.

NEVILLE gives AARON a look.

I only know because I saw Mum put it there.

NEVILLE looks in the bottom cupboard and finds the rum. He pours two glasses. AARON accepts. NEVILLE raises his glass.

NEVILLE: To my son and his new job. A photographer for the *Evening News*.

AARON: (*Grins.*) Cheers Dad.

They both raise their glasses and then down the rum in one go.

NEVILLE: Aaahhh.

NEVILLE immediately pours another glass for them each.

AARON: It's a weekday Dad.

NEVILLE: One more won't hurt.

AARON: Yeh but Mum will, if she finds out.

NEVILLE: Me not scared of your mum.

AARON: Just go easy Dad.

NEVILLE and AARON say cheers again but this time they sip the rum.

NEVILLE: So, this job of yours – good pay?

AARON: Yeah. Looks like I'll be able to rent a flat.

NEVILLE: What about buying a flat?

AARON: Let me do this in my own time. It's not a race. I'll get there eventually.

NEVILLE goes to pour himself another glass but AARON swipes the bottle and replaces the lid.

NEVILLE: Hey! Hey!

AARON: I don't want you using me as an excuse to get drunk.

AARON stashes the bottle.

Mum'll kill you and then she'll mash me up.

AARON helps his dad up.

And you've got to drive a bus first thing in the morning. Passengers don't want their driver sitting there with a hangover.

NEVILLE: Okay, okay… How's Saffron?

AARON: She's okay.

NEVILLE: I thought you liked her!

AARON: I did. But it wasn't really working. Bit obsessed with money.

NEVILLE: Pretty gyal though.

AARON: All that glitters is not gold.

NEVILLE: Me wish you could find yourself a nice gyal.

AARON: Me too.

NEVILLE: Really?

AARON: Women are so scary these days. Not like in your time. So demanding, so sure of themselves. Careers, babies, holidays, where they eat, go out…

NEVILLE: If dem so scary how come you had so many of them?

AARON: Me jus' like me 'ooman.

NEVILLE can't help but giggle at this. He slaps palms with his son.

NEVILLE: Son, when you find the right gyal though, she will fill your heart and mind until there's no more room for anyone else.

AARON: Yeh?

NEVILLE: You don't believe me?

AARON: I believe you.

They exit together.

SCENE 4

We are in the Mukherjees' lounge. MONTU, the ghost of CHITRA's late husband, enters. He looks elated and happy to be there. He is dressed in the traditional white garments of an Indian man (dhoti etc). He looks around the room. CHITRA enters carrying bags of shopping. She stares in horror, screams and drops her bags of shopping.

MONTU: God grief woman – I thought you'd be a little happier to see me.

CHITRA looks like she is about to have a fit. MONTU moves closer but CHITRA screeches and backs away.

Bul-Bul!

CHITRA collapses and faints.

Shit.

SCENE 5

We are on a tiny balcony at night outside the flat. Loud music in the background and the sounds of people having a good time at an office party. FRAN and ANITA are out on the balcony having a sly cigarette. ANITA is a little drunk.

FRAN: Just hope the landlady doesn't catch wind.

ANITA: She hates the idea of anyone having a good time. Witch.

FRAN: One of these days I'll buy a place.

ANITA: Hard on your own.

FRAN: Maybe we should buy a place together.

ANITA: That'd be too much like commitment.

FRAN: Know what you mean. I like you but I don't wanna pick out curtains or anything with you.

ANITA: Feeling's mutual babe. So why you bring me out here? You wanted to talk?

FRAN: Yeah.

ANITA: What? Nothing heavy I hope.

FRAN produces a wrapped present.

FRAN: Happy birthday babe. Thought you should open this in private.

ANITA excitedly opens the package. It is a large vibrator in the shape of a penis.

ANITA screeches with delight and switches it on. It makes a loud buzzing noise.

ANITA: Ace.

FRAN: No need for a microscope.

FRAN hugs ANITA.

Welcome to your thirties.

ANITA: Brilliant present. Never had one of these before.

FRAN: Sunday mornings will never be the same again.

ANITA: Hey, Aaron Jackson's in there.

FRAN: Yeah?

ANITA: Didn't you see him? He was eating me up with his eyes from across the room.

FRAN: I never noticed.

ANITA: He's so fit.

FRAN: Where've you been Anita? Aaron Jackson? Plays the field like he's picking off ducks at a fairground.

ANITA: Shame.

FRAN: He's bad news *and* he's a typical black man.

ANITA: Meaning?

FRAN: (*Lists a stream of women.*) Saffron…Debbie…Suzy… Milly…Izzy…

ANITA: Leggy blondes.

FRAN: I rest my case.

AARON pops his head out.

AARON: Ahh…found it. Smokers corner. Ladies? Mind if I…

FRAN frantically tries to hide the vibrator

FRAN: Be our guest.

AARON squeezes himself onto the balcony. He pulls out a cigarette from behind his ear but doesn't light it.

AARON: Promised myself last year when the ban came in that I'd give up.

ANITA: Me too.

AARON turns to ANITA

AARON: Name's Aaron.

ANITA: Anita.

They shake hands formally. AARON gazes into ANITA's eyes.

AARON: Happy Birthday.

FRAN pushes in between them.

Oh er…

FRAN: (*Reminding him of her name.*) Fran.

AARON: Fran…of course. How could I forget?

FRAN: (*Loaded.*) How could you?

The vibrator starts to buzz by accident. AARON looks around trying to work out where the noise is coming from. FRAN and ANITA stifle their giggles and try desperately to find the 'off' button. Eventually they manage to quieten the thing down.

A voice from within calls out.

VOICE: Fran! Fran! Come and have a look at this. It's hilarious.

FRAN: Better go. See you in there.

AARON: Yeah – sweet.

FRAN squeezes past ANITA and back into the party. She gives ANITA a meaningful warning look.

I seen you around.

ANITA: Yep. I seen you too.

AARON: Nice place you got.

ANITA: Been here for a couple of years now.

AARON: Very white area.

ANITA: Is a bit. But I quite like it.

AARON: Do you? Why?

ANITA: Well, don't have the problem of any nosy auntiejis with their twitchy nets knowing my business.

AARON: Get that a lot do you?

ANITA: You joking? It's like the secret service out there. Loads of plain-clothes sari detectives with walkie-talkies patrolling the streets.

AARON: (*Laughs.*) I get you. So, you work with Fran?

ANITA: Yeah – I'm a partner…a solicitor, in a small practice. Tribunal cases, that sort of thing.

AARON: Solicitor? Now I had you down as someone in the fashion industry.

ANITA: Really?

AARON: You got a lot of style.

ANITA: (*Amused.*) Yeah?

AARON: I thought you were a…model or something. From the tip of your head to the top of your head, you is pure sweetness.

AARON looks ANITA up and down lasciviously.

ANITA: (*Cold.*) Is that right?

Beat.

AARON: Sorry that was a bit naff wasn't it?

ANITA: Totally.

ANITA stubs out her cigarette and moves to get off the balcony.

AARON: Go on, give me another chance. Don't run off.

ANITA: You blew it.

AARON: I know. Sorry. Stay. Please.

ANITA looks irritated but she stays put.

Start again?

ANITA: Okay, okay… I'm surprised though – thought I wasn't your type. Or are you just desperate tonight?

AARON: You're really beautiful.

ANITA: But I'm not blonde.

AARON: What's that supposed to mean?

ANITA: Word gets around.

AARON: That's not fair.

ANITA: Girls talk. We swap disaster stories.

AARON: Surely if you're a solicitor you should be willing to hear both sides? Justice and all that?

ANITA: There's no smoke without fire.

AARON: Try me out, you might like getting burnt a lickle.

ANITA: Give me a break.

AARON: I see you across the room and I think to meself, that's the girl I'm gonna marry.

ANITA: What are you on?

AARON: You're perfect.

ANITA is not impressed.

Why don't we split from here, find some place with some atmosphere?

ANITA: Do I look completely stupid to you?

AARON: Anita. Do you believe in love at first sight or should I walk by again?

ANITA: Cheesy.

AARON: Feel my heart.

AARON grabs ANITA's hand and places it on his chest.

Everytime I see you my heart starts thumping girl! So loud, I think everyone can hear it in the room.

ANITA keeps her hand on AARON's chest for a while and then pulls it away.

ANITA: Do you propose marriage to every woman you meet?

AARON: No! Never done it before. But now I'm close up, I can see you're even more beautiful. Lotus eyes I could drown in…

ANITA is getting pissed off now.

ANITA: Stop it, you're embarrassing yourself.

AARON: We could fit like hand in a glove. Imagine what our babies would look like. Asian, African – beautiful mix.

ANITA: Can I get past you please?

AARON: Sure.

AARON stands back to allow ANITA past him. Then he grabs her and is about to kiss her when FRAN sticks her head out again.

FRAN: Anita – it's your mum on the phone. Sounds pretty urgent.

ANITA: (*Flustered.*) Oh…thanks…okay… Excuse me.

ANITA pushes past AARON.

AARON: You didn't give me your phone number! Hey! Don't forget, my name is Aaron. Remember it, 'cos you are gonna be calling it for the rest of your life.

ANITA disappears. AARON is left on the balcony, still clutching his unlit cigarette, grinning. FRAN comes back out again and stands next to him.

FRAN: You fraud. You don't even smoke.

AARON: Hey, Fran – sorry about earlier.

FRAN: How could you forget my name?

AARON: Don't be like that babe. It was a momentary…lapse… y'know wot I'm like?

FRAN: I know exactly what you're like. And I also know that Anita's too smart for you.

AARON: You still mad at me?

FRAN: No.

AARON: We were at school. Lot of water under that bridge. And if I remember correctly, you were the one that dumped me.

FRAN: You didn't seem to be too broken-hearted at the time.

AARON: Hey, we were both young.

FRAN: Anita would eat you for breakfast.

AARON: Sounds like fun.

FRAN: I don't think so.

They stand there in silence together.

AARON: You gonna give me her phone number then?

SCENE 6

ANITA hands over the brandy which CHITRA gulps back obediently. ANITA rubs her mother's back.

ANITA: I was really worried about you when I got your call… I thought something awful had happened…

CHITRA: He was dressed in white…he looked so well… I'm telling you, he was there. As clear as day, he was there, talking to me, making fun of me like he used to.

ANITA: Ma.

CHITRA: Don't look at me like that! I'm not mad. You smell of cigarettes. You been smoking? It's a disgusting habit.

ANITA sits down.

ANITA: You gotta move on. You gotta stop this stuff. You thought about bereavement counselling?

CHITRA: I am not mad and I will not wash my dirty underwear in public with a stranger.

ANITA: But maybe if you got out more…

CHITRA: I go to work every day.

ANITA: Yeah but you're a receptionist in a doctor's surgery mum.

CHITRA: Head receptionist.

ANITA: Head receptionist – okay. It's hardly a bag of laughs having to deal with all those sick people all the time… Maybe if you saw some of your old friends…what about Apu auntie or Meera aunty…?

CHITRA: I can't.

ANITA: Why not?

CHITRA: Because they laugh at me. Always asking me – how is Anita? Is she married yet? What is she doing? Has she got a boyfriend? I feel…shamed!

ANITA: Yeah, right – it's all my fault.

CHITRA: By your age, I had two children in secondary school.

ANITA: You were a child bride.

CHITRA: And you will be a spinster. You will be past your sell-by date, on the shelf, soiled goods.

ANITA sighs

Look at your cousins! All three married, settled, good husbands and Joolie is expecting again.

ANITA: Stop it.

CHITRA: And Asha – failed all her exams but look what a nice house she's got.

ANITA: Please…

CHITRA: Why won't you at least meet some boys?

ANITA: Ma, why are you all so obsessed with marriage? As if there's nothing else to life?

CHITRA: What else is there?

ANITA: Why won't you leave me alone? All this emotional blackmail!

CHITRA: You call your own mother a blackmailer?

ANITA: It's my life Ma.

CHITRA: No, I gave you life, so it's my life too. I came to this country, your father and I struggled for years to give you

and your brother a decent education, a start in life, more opportunities than either of us had.

ANITA: There you go again. Emotional blackmail.

CHITRA: We made sacrifices.

ANITA: And now it's payback time?

CHITRA: Don't you dare talk to me like that? If you fail then I have failed.

ANITA: So now I'm a failure?

ANITA gets up and moves towards the door.

CHITRA: At the school gates, none of the English mothers talked to me. But did that stop me? No! I was there everyday waiting for you, in the wind, in the rain…

ANITA: I am not going to marry some boring Bengali accountant just because you want me to.

CHITRA: What happened to Kiren? I liked him!

ANITA: I told you what happened to him.

CHITRA: A whole year you were with him and then suddenly – poof! Vanished!

ANITA: All the time he was seeing me, he was chasing after white girls.

CHITRA: Are you sure?

ANITA: I saw it with my own eyes. I told you Ma. Why do you keep on at me about Kiren?

CHITRA: I want you to be happy baby. Then I can die happy.

ANITA: You know what would make me happy? For you to back off, to leave me alone, to let me live my own life, to stop nagging me day in day out, to get a life and stop living yours through mine.

CHITRA: You will end up a lonely old woman.

ANITA: Like you?

CHITRA bites her lip, upset.

I'm sorry. Look, I know you miss Dad, but so do I.

CHITRA: No you don't. You are too busy running around, getting drunk, having sex with strangers.

ANITA: What?

CHITRA: I know. I have ears. I hear things.

ANITA: Aunty Meera?

CHITRA: Everyone knows about you. You behave like a…like a…prostitute!

ANITA looks upset and then storms out.

Anita? Where are you going?

The front door slams shut.

SCENE 7

INDIA, a thirteen-year-old mixed-race girl in school uniform is sat at the Jacksons' dining table picking at her food. AARON is sat opposite her. He is cleaning his camera lenses etc. Throughout this scene AARON keeps checking his phone for messages.

INDIA: What happened to Saffron?

AARON: Didn't work out.

INDIA: Why?

AARON: She was a bit…shallow.

INDIA: Great legs though.

AARON looks up at INDIA.

AARON: Eat up. Your Gran went to a lot of trouble.

INDIA: How come you can never keep a relationship down?

AARON: Haven't met the right gyal yet.

INDIA: You picky or just a player?

AARON: A player? Where' d you learn words like that?

INDIA: That's what mum says you are.

AARON: Your mum should keep her opinions to herself.

INDIA: She says you have 'commitment issues'. But then, you've always been there for me, so you're alright as far as I'm concerned.

AARON smiles.

AARON: Thank you for that vote of confidence.

INDIA: Feel sorry for your girlfriends though.

AARON: There's only one girl for me.

INDIA: That's a bit weird. Can I remind you that I *am* your daughter so you shouldn't build your entire world around me 'cos one day, I'll be all grown up and'll have flown the nest.

AARON: I didn't say it was you.

INDIA shrieks and throws a dumpling at AARON's face. AARON laughs as LETICIA walks in. She is dressed in a nurse's uniform.

LETICIA: What's this India? You throwin' good food around?

INDIA: Sorry Gran. Dad was being mean. It's really delicious. Thanks.

LETICIA: Eat it up then and don't play with your food. Plenty starvin' children in India – India – would gobble that dumplin' you hurlin' about the place.

AARON: Starvin' people all over the world Mam, not just India.

LETICIA: It was just a turn of phrase… Gotta get to work… Aaron, you have to do that while your girl's eating?

AARON: Just finishing off now.

LETICIA: What you two up to today?

INDIA: Bowling.

AARON: She's going to let me thrash her again.

INDIA: Lame.

AARON: Then we're going to go for a walk in Alderley Edge.

INDIA: Freak!

LETICIA: Remember, India's mum wants her back by seven. Last time you were both two hours late and Michelle was not happy.

INDIA: Mum's such a control freak. I texted her to tell her…

LETICIA: But that wasn't the agreement. You have to stick to arrangements. And don't let me ever hear you calling your mam names again India.

INDIA: It's true. She's a total mare!

LETICIA: I will not entertain you bad mouthing…

INDIA: Gran! I've got a time table. From the moment I wake up in the morning 'til bed time. Seven o'clock – wake up. 7.05 – brush teeth. 7.10 – get dressed. 7.25 breakfast. 7.45 – go to school. Then it all starts again at four o'clock. I'm only allowed three hours a day of 'visual screen time', as she calls it.

LETICIA: What's that?

INDIA: Telly, computer, Playstation. Got a timetable for every day of the week – even including Sundays. You tell me – is that normal?

LETICIA: (*Disturbed.*) Well…

INDIA: 'Least when I come here, you let me be. It's more laid back.

LETICIA: Yes, but your mam's English – and dem English like dem organisation. Nutten wrong with that.

AARON: That's how they organised the world. Africa, Ireland, India, the Americas…none of it could have been done without meticulous, detailed planning and organisation.

LETICIA: (*Warning.*) Aaron.

AARON: Your mum's only trying to make sure you don't waste your time.

INDIA: Sometimes it's nice just to be. Don't feel like I'm human – more like a robot.

AARON: You want me to talk to your mam?

LETICIA: Stay out of it Aaron.

AARON: It's a bit weird though isn't it?

LETICIA: You must not interfere with Shell's parenting. She work hard and this is her way of bringing up her child.

AARON and INDIA exchange glances.

And you, India my girl, must stop stirrin' the pot.

LETICIA gives INDIA a fierce look and exits.

AARON: She means 'shit' stirring.

INDIA giggles.

LETICIA: (*Off.*) Wash your mouth out! I will not have dat language in my house…an' in front of a chile. Shame on you!

AARON: (*Calls out.*) Sorry Mam!

AARON picks up his mobile phone and starts texting.

INDIA: Who are you texting now?

AARON: None of your business.

INDIA: Is it a new girlfriend?

AARON: Like I said…

INDIA: You really need to settle down Aaron.

AARON: Can you just…?

INDIA: I mean look at you? You're a stereotype.

AARON: I beg your pardon…?

INDIA: Black man, baby father, blonde girlfriend you got pregnant when she was a teenager…

AARON: She was twenty when she had you.

INDIA: Yeah, but she was nineteen when you got her up the duff. Drifting from job to job, still living at home! How old are you? Thirty-two? I mean, really Aaron.

AARON: You talk too much.

INDIA gets up and takes her plate to the sink.

INDIA: Who is she?

AARON: How you know it's a 'she'?

INDIA: Because you keep checking your phone. You're like – really worried.

AARON: No I'm not.

INDIA: Yes you are. You check your phone for messages and then look really upset when there's no message. Only a girl does that to you.

AARON: This one's no girl.

INDIA: What is she? A supermodel?

AARON: No. She's all woman.

INDIA looks interested.

She won't return my texts though.

INDIA puts her arms around AARON who welcomes the hug. He looks a little forlorn.

INDIA: Is she the 'one that got away'?

AARON: Where do you learn these phrases from?

INDIA: C'mon, I'll help you to write one.

INDIA sits down ready to help her dad with his love life.

AARON: You think I'm gonna learn how to pull from a thirteen year old?

INDIA: You got nuthin' to lose. I mean, you haven't exactly been very successful have you? Give us your phone.

AARON looks doubtful as INDIA holds out her hand for his phone.

Bet you've been coming up with some really lame lines.

AARON shakes his head.

Trust me – 'Dad'.

SCENE 8

CHITRA is asleep on the arm chair. MONTU is sat at the table, pouring some tea. CHITRA awakes and walks across slowly to him.

MONTU: Good morning. I've made you some chai. Just how you like it.

CHITRA approaches MONTU. She touches him.

I'm looking good eh?

CHITRA: Montu? Is that you?… But how? How is it that…?

MONTU: You called me. Kept calling me on the phone. Remember? I kept trying to call you back but…

CHITRA: All those calls…that was you?

CHITRA is speechless.

MONTU: What did you expect? You pray like a maniac day in day out. 'Montu, where are you when I need you? Montu, come back! Montu our daughter is in peril.' So I drag myself back. I was in Paradise! I was relaxing, enjoying myself. Floating around and then you keep calling me and now – look.

MONTU sits in a chair with his arms folded.

CHITRA: What have you been doing all this time? Three years…?

MONTU: I can't tell you what I've been doing. Sworn an oath of secrecy…but I *can* tell you in future, if you want to speak to me, you can just text me. I've had a word with the people here and they've agreed.

CHITRA: What people?

MONTU: The people in charge here.

CHITRA: You have guards?

MONTU: No. Not guards exactly…more…how shall I put it? The keepers of the peace. They double up as Angels. Nice people. I thought I'd come back and help you out.

CHITRA: Forever?

MONTU: Nothing is forever Bul-Bul. Limited time.

CHITRA: Just until Anita is married.

MONTU: Ah yes...Anita... Why do you always worry so much?

CHITRA: Because there's only me now. A widow with a spinster daughter. You left me to deal with this all on my own.

MONTU: I didn't exactly invite the grim reaper into the hospital.

CHITRA: I'm too young to be a widow.

MONTU: I'm sorry. But I refuse to accept the blame.

CHITRA: Always working too hard, never taking your blood pressure tablets and smoking...smoking...

MONTU: I never thought I'd say this but I've missed your nagging.

CHITRA: (*Angry.*) You left me on my own – abandoned me. No warning, no goodbyes. I keep knocking on the door and there's no reply.

MONTU: I'm here now.

MONTU hangs his head. CHITRA tries to hold back her angry tears.

CHITRA: I don't know what to do.

MONTU: I'm here now. Tell me, what is it exactly that you want?

CHITRA: Anita to be settled...grandchildren...people out there whisper behind my back. An unmarried daughter is a stain on the family honour...on *your* honour...

MONTU looks puzzled.

41

MONTU: Honour?

CHITRA: You may have left all that behind but I still have to deal with it… Montu…can you come back?

MONTU: No.

CHITRA: But how is…your body…? I cremated you…I thought there was nothing left…

MONTU: What you see is a manifestation of my last earthly body on earth. It's not real…like a photograph.

CHITRA: You look…

MONTU: Younger? Celestial makeover.

CHITRA dabs her eyes with a handkerchief, which she produces from her blouse.

CHITRA: I knew you couldn't have completely abandoned me. I felt you close a few times. A flash of light sometimes, a whisper, your scent, even in my sleep, I often felt you lying next to me.

MONTU: Ahhh…so you *have* been aware.

CHITRA: (*Starts to weep.*) I miss you.

MONTU kisses his fingers and reaches out.

MONTU: (*Gentle.*) Stop your blubbering woman. Look Bul-Bul, don't go around telling people you've seen me. It sounds, it sounds…a little strange and you will end up in a psychiatric hospital diagnosed with delusional psychosis.

CHITRA: And whose fault is that?

MONTU: I came for you; you were the person who called me. The bosses here won't allow me to manifest myself to anyone else so let's just keep this between us – okay?

CHITRA nods.

Now, let's start at the beginning. Let's analyse this 'problem' you have.

CHITRA: It's our problem.

MONTU: With all due respect…

CHITRA: Just because you're no longer here, doesn't mean you can abdicate responsibility.

MONTU: Okay, okay…but you can't force things through your sheer will.

CHITRA: She won't even let me introduce her to any boys.

MONTU: She wasn't brought up that way.

CHITRA: Nowadays, arranged marriages are like a dating agency.

MONTU: Even we didn't have an arranged marriage.

CHITRA: We were different. The world has changed Montu. Love like that doesn't exist. It's much more cynical these days.

MONTU: Is it?

CHITRA: They have sex at the drop of a hat these young people. They don't know the meaning of commitment or the ideal of marriage.

MONTU: It hasn't changed that much Chitra. Different dance maybe, but same result.

CHITRA: Like you would know!

MONTU: I know this much. You have to get a life for yourself Chitra. Stop living in the past and meddling in Anita's affairs. In time, she will find someone herself.

CHITRA: I'm sure she'll find someone but will he be a suitable boy? Will he be from the right kind of family? Caste? Class? Will he be of good educated stock?

MONTU: What does all that matter? As long as she loves the boy?

CHITRA: What boy?

MONTU: There is someone Chitra.

CHITRA: How do you know?

MONTU: And you have to rise to the occasion Chitra. Push all your prejudices aside and welcome the boy with open arms. If you don't you will lose her.

CHITRA: What boy?

MONTU: He is the one. She will choose soon and there is nothing you can do about it.

CHITRA: Who is he? Do we know his family?

MONTU: Remember what I said.

CHITRA: Montu, what are you talking about?

MONTU exits.

You come back here at once! Montu! Montu!

CHITRA sobs.

SCENE 9

ANITA and FRAN are back in a bar, drinking after work.

ANITA: She called me a prostitute!

FRAN: That's unfair. I mean you never do it for financial gain…do you?

ANITA: Fran!

FRAN: I was just joking. You're really worked up aren't you?

ANITA: She's a bloody nightmare.

FRAN: Just take a break from her for a bit.

ANITA: Nothing I ever do is good enough. Even my job…

FRAN: What's wrong with your job?

ANITA: It's not flash enough for her. You know she goes round lying to people? Says I'm a senior partner in some corporate law firm.

FRAN: Like Ally McBeal?

ANITA: Yeah.

FRAN: My mum barely speaks to me Anita. Thinks I'm a freak.

ANITA: Count yourself lucky. What's the point in being a parent when all you do is put your kids down?

FRAN: She do that with your brother?

ANITA: Oh no – Pradeep can do no wrong – even though he's fucked off across the water. Barely sees her – phones her once a week – and she thinks the sun shines out of his arse.

FRAN: Brothers eh?

ANITA: And now Ma's claiming she sees my dad's ghost!

FRAN: That is a bit worrying. D'you think maybe she's going a bit…

ANITA: Loopy? Definitely. And I can't believe you gave that creep my phone number.

FRAN: Aaron? I thought you liked him.

ANITA: He's texted me ten times since last night.

FRAN: What's he said?

ANITA picks up her phone and reads out some of the texts from her phone.

ANITA: 'Babe – My lips are so cold without yours.'

FRAN laughs.

'Cupid called and said to let you know he needs my heart back.'

FRAN: Shit, that's bad.

ANITA: Listen to this one. 'Your legs must be tired 'cos you've been running through my mind all day.'

FRAN: Weak.

ANITA: 'If a kiss is the language of love then we have a lot to talk about.'

FRAN: Shakespeare!

ANITA: 'If I could rearrange the alphabet I'd put U and I together.'

FRAN: Hey – at least he's got a sense of humour.

ANITA: He's obviously used these lines before. 'Excuse me, have u got a map? Because I got lost in your eyes.' And this was the last one: 'There's only 2 times I want to be with u, now and forever.'

ANITA's phone beeps again. She checks the message.

This'll be the eleventh…

'Joking aside Anita, would love to take you out for dinner. Can't stop thinking 'bout you. Promise no more cheesy lines. Please say yes. Respect. Aaron.'

ANITA looks taken aback

FRAN: (*Amazed.*) That's quite sweet.

ANITA: Yeah.

FRAN: Maybe, you should go out with him.

ANITA: No way.

FRAN: You'd be good for him.

ANITA looks at the text.

ANITA: One thing's for sure, it'd really piss my mum off.

FRAN: What?

ANITA: If I came home with a black man. She'd go ape-shit.

ANITA laughs mischievously to herself.

FRAN: That'd be like using him to get back at your mum.

ANITA: Exactly.

FRAN: Hey – Anita – that ain't fair. You shouldn't mess with people's feelings.

ANITA starts texting.

ANITA: You think Aaron Jackson has any feelings for women? We're all there to just service his ego.

FRAN: What you doing?

ANITA continues texting.

ANITA: Just having a little fun.

SCENE 10

LETICIA and NEVILLE are dressed and ready to go to church. LETICIA is tying NEVILLE's tie.

LETICIA: I haven't seen the boy in days.

NEVILLE: That's good isn't it?

LETICIA: He promised me he would come to church with me this morning.

NEVILLE: Did he? That not like him.

LETICIA: He needs to pray.

NEVILLE: We can pray for him.

LETICIA: Shell and India meetin' us there.

NEVILLE: In that case, him definitely be there.

LETICIA: Keep callin' him on his mobile but him not picking up.

NEVILLE: Maybe him meet us there.

LETICIA: Claudette tell me her boy see Aaron out last week in that new 'sweet spice' restaurant at night.

NEVILLE: I hear it's home cooking away from home. We should go there too one night.

LETICIA: Aaron with a pretty gyal.

NEVILLE: (*Chuckles.*) That's my son.

LETICIA: Him say dem spend de entire evenin' gazin' in to each other's eyes.

NEVILLE: Your cousin son always was a nosy rascal. Ask him if was out wid him mistress.

LETICIA gives NEVILLE a look. We hear the front door slam. AARON rushes in.

AARON: Am I late?

LETICIA appraises her son's clothes.

LETICIA: Lord have mercy. Look at the boy. You haven't got time to get changed. Neville, get him a tie.

AARON: I'm not wearing a tie.

LETICIA: You come to church. You have to look respectable.

AARON: I've had a shower mum.

LETICIA: I can't be seen with you…

NEVILLE: Leave him alone Letty. The Good Lord's hardly going to be sitting up there giving him marks out of ten for his outfit.

LETICIA: You spoil him Neville. Anyway, it's about showing respect… Aaron – where you been?

AARON: Stayed at a friend's.

LETICIA: What fren'?

NEVILLE: Letty…

AARON: Nice hat mum. In fact you look beautiful.

AARON gives LETICIA a big kiss on the cheek and a big hug. LETICIA squirms out of her son's arms and looks a bit shocked. AARON sits at the table and sighs happily. NEVILLE and LETICIA stare at their son.

LETICIA: Aaron? What's going on?

AARON: What?

LETICIA: You look like an eedyat.

NEVILLE: Your mudder want to know – who dis gyal you been seeing?

LETICIA: Your fadder want to know too – he jus' pretending he don't.

AARON grins stupidly.

Him lose his tongue.

AARON continues to grin.

NEVILLE: Who is she?

LETICIA: What her name?

AARON: What is this? The Spanish Inquisition?

LETICIA: There's something funny going on. I know you Aaron. Your father know you too.

NEVILLE: I don't think anyone can know anyone really…

LETICIA: Hush up Neville.

NEVILLE: Don't you tell me to hush woman!

AARON: Alright! Alright!

Beat.

Mam, Dad… I've met this girl.

LETICIA: How long you know her for?

AARON: Six weeks.

LETICIA: Not long then.

AARON: When you and Dad met you said, you knew straight away.

NEVILLE: That's because your mudder got me into a head-lock.

LETICIA: I did not! Your fadder follow me around for a whole month informing me we gettin' married. I didn't even know him! Who dis gyal?

AARON: (*Sighs.*) Anita.

LETICIA: Anita? She Clarice's dawta?

AARON: No.

LETICIA: Who is she then?

AARON: Anita Mukherjee. And she's beautiful.

NEVILLE: Mukherjee?

LETICIA: What kind of surname dat?

NEVILLE: Indian.

AARON nods.

LETICIA wobbles and sits down, concerned.

LETICIA: You seein' an Indian gyal?

AARON nods.

AARON: You'll love her. She's pretty, intelligent, funny…

LETICIA: Muslim?

NEVILLE: No, it's a Hindu surname.

LETICIA: How you know these things? They all the same – Hindi, Muslim.

NEVILLE: Hin*doo*, not Hin*di*. Anyway, I know a Mukherjee. Takes the number 51. Regular as clockwork for ten year now.

LETICIA: Six weeks you say?

AARON: Six, blissful weeks.

LETICIA: Lord have mercy.

AARON looks at his watch.

AARON: I promised India I'd see her at church today. Give me two minutes, I'll get changed into a suit.

AARON exits.

NEVILLE: I never seen him like that before! I think he might actually be…

LETICIA: We have to stop it.

NEVILLE: Why?

LETICIA: She'll tek him away from us.

NEVILLE: I thought that's what we wanted?

LETICIA: Not with one of dem!

NEVILLE: Letty!

LETICIA: Dem all live pack up in one house an' you don't know who married to who.

NEVILLE: Awww…come on…

LETICIA: And dem always short change you. You know what dat Patel family are like. Everytime, have to check your change before you leave the shop.

NEVILLE laughs.

Don't laugh! Dis is serious! Indians – I see dem in the hospital – all o' de time. Doctor's, nurses…always dem look down dem noses at me. Like we descended from slaves.

NEVILLE: Which we are…and we should be proud of it.

LETICIA: Worse dan dem Nigerian traffic warden. You know de look – like we not even worth talking to. Only las' week dis Indian 'ooman in de hospital – she refuse to let me touch her. Me have to turn her and she call out and ask for a white nurse. Treat me like dirt beneat' her foot.

NEVILLE: That's bad but dem not all like dat.

LETICIA: Dem Indians, dem give me shade once too many time. Dey not better than me! Speakin' in their secret lickle language to each other, excluding me.

NEVILLE: Letty, please, don't let Aaron hear you talk like this.

LETICIA: I only speakin' the truth! Just because we similar in colour, no matta! We like from differen' planets. Sometimes, mixin' don't work. You tink her family will accept him?

NEVILLE: You talk like dem gettin' hitched. Him only know her for six weeks.

LETICIA: But de boy is in love. You not see it?

NEVILLE: I see it.

LETICIA: Indian people, dem not mix. Dem hate us and dem smell bad.

NEVILLE: Me ashame on you Letty. Absolutely ashamed. After everything we face when we came here, I not expect you to speak like…like…a white person.

NEVILLE leaves the room.

LETICIA sits on her own, her face full of anxiety.

SCENE 11

ANITA and AARON are lying in bed together. They have obviously just had sex.

ANITA: What day is it?

AARON: Sunday.

ANITA: That means we've been in bed all weekend.

AARON: So?

ANITA: Lying in our own filth.

AARON: So?

ANITA: We've gotta get out.

AARON: Why? It's miserable out there. Raining, pouring.

ANITA: Actually, it's sunny.

AARON: Is it?

ANITA: I peeked out earlier. There were kids playing footie in the street.

AARON: You wanna play footie?

AARON plays with ANITA's feet under the covers with his feet. ANITA squirms and giggles.

ANITA: Stop it!

They tumble in bed together, play fighting etc.

AARON: I knew it from the moment I set eyes on you…

ANITA: You were so cheeky.

AARON: And you were so frosty.

They kiss.

So what're we gonna call our first child?

ANITA: Shut up.

AARON: If it's a girl, I quite like the name Cassandra.

ANITA: Has to be an Indian name.

AARON: What, like Anita?

ANITA: Okay, so that was just my parent's attempt to integrate. What does Aaron mean?

AARON: 'Exalted one' or 'high mountain'.

ANITA: Yeah right…

AARON: He was the older brother of Moses and the first High Priest of the Israelites.

ANITA: How the mighty have fallen.

ANITA laughs, AARON starts to tickle ANITA. It starts getting heated but they are interrupted by an urgent knock on the door and FRAN barges in. AARON dives for the sheet to cover himself. FRAN takes in the situation and enjoys AARON's embarrassment.

Fran? Everything alright?

FRAN: No. It isn't.

ANITA and AARON exchange a look.

(*Anxious.*) Anita, emergency stations.

ANITA leaps out of bed like she's had an electric shock. She immediately starts getting dressed hurriedly.

ANITA: Shit.

FRAN: I'll stall but you've got three minutes… And hide him… somehow… Hey, Aaron, you've put on a bit of weight.

FRAN exits. AARON watches with total confusion.

AARON: What the hell…?

ANITA puts her fingers to her lips.

ANITA: Not a word. You stay put here. You do not leave the room, you do not move or make a sound.

AARON: Anita?

ANITA: It's my mum. She's come on one of her surprise swoops.

We hear the door buzzer go.

Shit…shit…fuck…shit…

ANITA is hopping around trying to put her socks on at the same time as brushing her hair and spraying herself with deodorant.

AARON: But I want to meet your mum!

ANITA: Trust me, you don't.

AARON: But I do!

ANITA: Shhhh…!

AARON: You ashamed of me?

ANITA: Yes!

AARON: It's been two months – surely we should come clean…

ANITA: Please Aaron, do this for me…please…just stay low and I'll get rid of her.

FRAN: (*Off – Ostentatiously loudly.*) Hello Mrs Mukherjee! How nice to see you!

CHITRA: (*Off.*) Hello Fran. Shall I go straight through…?

ANITA: No!

FRAN: (*Off.*) Erm…she's just in the shower. Can I get you a cuppa while we wait for her?

CHITRA: That would be nice. Thank you.

AARON: (*Whispers.*) Anita – why're you behaving like this?

ANITA: (*Whispers back.*) You don't know what my mum's like.

AARON: You're a grown woman…

ANITA: Try telling her that!

AARON: I've gotta meet her at some point !

ANITA: Shhh…she'll hear you!

AARON gets out of bed – he is naked. He stands confused and upset. He holds onto ANITA's hand and won't let her go.

AARON: I don't think this is right. You trying to hide me because I'm a black man? I'm just a bit of stuff that you shag but anything more serious and …

ANITA: Please keep your voice down Aaron!

AARON: Let me get some clothes on and then I can go out and meet her.

ANITA: Let me go. I have to… Look, this isn't the time or the place.

ANITA opens a wardrobe.

AARON: I am not getting in there.

ANITA: Right now, I need you to do this for me.

AARON: I'm not happy.

AARON sighs and climbs into the wardrobe. ANITA closes the door.

ANITA: Five minutes and then I'll get rid of her.

ANITA quickly rushes around picking up clothes, shoes, she opens the wardrobe momentarily and shoves them all in.

AARON: Ouch!

ANITA: Sorry.

ANITA is making the bed as the door opens and CHITRA enters.

CHITRA: Baby, I made your favourite fish curry… You still not up?

ANITA: Erm…mum…wasn't feeling too well.

CHITRA: Felt bad about the last time we…it's been six weeks…you've hardly called, you haven't come to see me…Let's be friends again huh?

CHITRA enters the room. She sniffs the air.

Smells a bit stale in here. Open the windows Baby.

ANITA: It's fine Mum…need to do a clear out. C'mon…let's have a look at this fish curry…is it hilsa?

CHITRA: Yes. Ahmed in Rusholme called me up, said he had some hilsa…so I went round immediately…just for you.

CHITRA sits on the bed and looks around the room.

So, how have you been?

ANITA: Okay. You?

CHITRA: I started a keep fit class…Baby, is something the matter? You seem…

ANITA moves over to the door.

ANITA: I'm fine… I'm due to see an old friend for tea…oh gosh is that the time?

ANITA looks at her watch ostentatiously.

CHITRA: I've just got here.

ANITA: Yeah – but you should have phoned before…

CHITRA: Oh – so now I have to make appointments to see my own daughter?

ANITA: Don't start Mum.

CHITRA: You don't care about me. Only when I am dead and gone will you finally understand how much your mother did for you. The sacrifices I made, the love I wrapped you up in. You take me for granted.

ANITA: Let's just cool down…c'mon Mum…

CHITRA gets up to follow ANITA out of the room. She spots some jeans trapped in the wardrobe door and moves across to pull it out

CHITRA: Honestly Baby, you still can't keep your room tidy. I bet you just stuff all your clothes into the wardrobe…

ANITA: No! Mum! Don't!

But it's too late. As CHITRA tugs at the jeans, the wardrobe door creaks open and CHITRA freezes as she comes face to face with AARON, stark naked, hiding in the cupboard. AARON tries to cover himself up with his hands. CHITRA is aghast. She screams. FRAN rushes in and stands next to ANITA. AARON looks terrified.

Act Two

SCENE 1

RAJ, a middle-aged Asian man is sat in CHITRA's lounge. His suitcase is sat by his side. CHITRA is bustling around him, waiting on him hand and foot. Throughout this scene, she hands him nuts, drinks, serviettes, pakoras etc. He sits like his namesake 'a king' and does not lift a finger.

CHITRA: Raj, thank you so much for coming. I was at the end of my…

RAJ: We are family and you know *Bowdi*, I am always here for you.

CHITRA: Thank you Raj.

RAJ: Now that we are both widowed, we must support each other in times of trouble. And you need a man to stand by your side.

CHITRA: My baby, in bed with a…black man.

RAJ: It *is* a very grave situation.

CHITRA: Back in Tanzania, if this had happened…she would have been beaten around the town.

RAJ: And he would have been shot.

CHITRA: Can you imagine my horror? It didn't even occur to me that he was a…a…'friend' of Anita's. I assumed he was a burglar who was hiding in her cupboard, ready to pounce on her.

RAJ: That would have been my immediate thought.

CHITRA: He was completely naked!

RAJ: Yes, you've told me that part several times.

CHITRA: I wanted to call the police and then that…that…
man…he put out his hand…which he'd been trying to
cover his genitals with…and tried to shake hands with me!

RAJ: *Chi! Chi!*

CHITRA: And she said: 'Mum this is Aaron'. And he said
'Hello Mrs Mukherjee. I'm sorry to meet you under such
embarrassing circumstances but I'm in love with your
daughter.'

RAJ: The nerve of the man…

CHITRA: Can I get you some more whisky?

RAJ: Please.

CHITRA takes RAJ's glass and bustles off to refill it.

(*Calls out.*) This time *Bowdi* could I have some ice?

CHITRA: (*Off.*) Of course!

*RAJ settles back in his chair and makes himself comfortable. CHITRA
bustles back in with some more whisky and ice in a glass. She hands
the drink to RAJ who sips it.*

RAJ: You've kept this house very nicely. And all on your own.
I always admired how you were able to keep down a job
and have a beautiful home.

CHITRA: Thank you.

RAJ: And you *Bowdi*…you are looking very…very…healthy.

CHITRA: I knew she was up to something. She had simply
disappeared for six weeks. But I never dreamed…not in a
million years…if Montu was here, he would know how to
handle the situation. I'm on my own. She won't listen to
me…

RAJ: And where is the girl now?

CHITRA: In her flat. She promised me she would come round soon to say 'hello' to you.

RAJ: So communications between you haven't completely broken down?

CHITRA: No.

RAJ: This boy…we have to end it.

CHITRA: But how? She's so stubborn…it runs in the family, just like her father…sorry Raj. I didn't mean you…

RAJ: Stubbornness is not always a bad attribute. Can I have some more of those pakoras *Bowdi*?

CHITRA pushes the plate of pakoras towards RAJ.

Thank you. The way I see it – We have three options. One, you accept the situation and let Anita make her own choices. Two, you try and persuade her gently as to the error of her ways. Explain how this match would never work. Three you threaten to disown her if she refuses to give up this negro

CHITRA: (*Dismayed.*) Disown her? You think that will bring her to her senses?

RAJ: Definitely. Joolie went through a similar 'phase', shall we call it.

CHITRA: Really? Your Joolie?

RAJ: She had a liaison at school with one her co-teachers. A Somalian. Brought him home with her one day – out of the blue! Said she wanted to marry him.

CHITRA gasps.

I told her, there and then on the spot. You marry this… this…man…and I will disown you Joolie. Never again will you see your mother, your sisters or me. You will never be able to walk back into this house, your children will never

know their grandparents and you will be cut off from the community forever.

CHITRA: Poor Joolie.

RAJ: It was the only way. This…man…

CHITRA: What was his name?

RAJ: I don't know… I can't remember… Mohammed, Ali, Jamal…something…

CHITRA: Muslim?

RAJ: Exactly. Not only Negro but Muslim too.

CHITRA: You never told me any of this!

RAJ: And I'm only telling you because it might help you. It was a very unsavoury episode in our family's history. Anyway, this man chased me round the house. Begging me to reconsider, pleading and claiming that he and Joolie were 'soul mates' – that I couldn't stop their love.

RAJ snorts.

I refused to look at him, I refused to acknowledge him and eventually he left the house.

CHITRA: What happened next?

RAJ: Joolie locked herself in her room for a whole week and cried. He wrote me a long letter calling me 'racialist'.

CHITRA: And Joolie?

RAJ: As you can see, she realised the error of her ways and she finished with this man. Within a year, we had fixed up a good marriage for her and now look at her! Good husband, settled in a nice house, children, another one on the way…she is happy!

CHITRA looks disturbed.

RAJ: A firm hand *Bowdi*. That is what is required. We are not animals, we do not beat our children or lock them up. We do not threaten to murder them like some people do but we still have to remind them of their obligations. Persuasion and discussion first and then you have to lay down the law. Has she talked about marriage?

CHITRA: No.

RAJ: Then we still have time. This match must be stopped at all costs.

CHITRA: Yes!

RAJ: His family will never accept her either.

CHITRA: I don't think she's met his family yet.

RAJ: Then let us nip it in the bud, so to speak.

CHITRA: How?

RAJ: We will call an emergency meeting, invite his family for a conference.

CHITRA: Do you think they will agree?

RAJ: I will talk to his father man to man. This is how things should be done, between the family elders.

CHITRA: You are such a help and support to me.

RAJ: Think of the family shame, the honour of our ancestors. This mixing of blood is not a good thing. Black, white, Jewish, Muslim, Chinese – it's all the same thing.

CHITRA: When we came to this country, we knew that our children would be brought up in a mixed environment.

RAJ: Have them as friends. Have them as colleagues, but there's no need to bring them into your family. We are a proud race with an ancient civilisation, a language, a religion. We mix, we dilute; we dilute we lose everything

we've fought for. Think of Montu. I know my brother, he would not want black grandchildren.

CHITRA: I don't know what Montu would say about this. I wish I could talk to him.

RAJ: He is gone *Bowdi* and nothing will bring him back. Just as my Shukla has gone. It is time for us both to move on and live our own lives.

RAJ looks at CHITRA with meaning. CHITRA is unsure.

You know, I have always greatly admired you and it is a lonely business, this widowhood. Perhaps…given time… you and I…

CHITRA's phone starts to ring with a rather bizarre ring tone.

RAJ: What on earth?

CHITRA: It's my phone; it's been playing up recently.

CHITRA tries to fiddle with the phone. CHITRA looks worried.

I can't seem to …

She holds the phone to her ear.

Hullo? Hullo? Keep getting these anonymous calls…no one at the other end…

RAJ gets up.

RAJ: Here, let me. I'll give them a piece of my mind…

RAJ takes the phone from CHITRA.

Now, listen here, whoever you are, I will get the police on to you. Shame on you!

There is a flash of static which gives RAJ an electric shock.

Aaargh!

RAJ jumps back in shock and drops the phone. RAJ collapses.

SCENE 2

AARON and ANITA are in her bedroom. ANITA is surrounded by paperwork on her bed and is trying to work. AARON is taking photos of her.

AARON: What are you working on?

ANITA: Bizarre case at work. Young woman – Chinese – really gorgeous. She worked for a PR company for a year and they gave her three written warnings about the 'inappropriateness of her dress'.

AARON: Why?

ANITA: Her mini skirts were apparently 'too mini' and it was distracting the clients.

AARON: Would have thought her bosses would love it.

ANITA: They didn't. My client is furious and wants to take the company to a tribunal for unfair dismissal on the grounds of sexual discrimination.

AARON: How short were her skirts?

ANITA: Virtually non-existent.

AARON: And did she have great legs?

ANITA: Up to her armpits.

AARON smiles.

Look at you. You're getting off just thinking about it.

They both laugh.

AARON: You're a high flyer aren't you?

ANITA: Me…nah…it's a small firm…

AARON: But you're a partner.

ANITA: You could have had your own studio by now if hadn't been running around chasing women.

AARON: You saying I'm not good enough?

ANITA: No. But you still live at home.

AARON: I didn't have the opportunities you had.

ANITA: I wasn't criticising you Aaron!

AARON: My mum's a nurse, Dad's a bus driver…

ANITA: Don't give me that.

AARON: Asian kids always did better than us at school. Bet you were a swot.

ANITA: Bet you were the class Casanova.

AARON: Girls always loved me.

ANITA shakes her head and laughs.

My parents keep wanting to meet you.

ANITA: Naked or clothed?

They laugh.

AARON: My dad would be delighted if you turned up naked. My mum… I'm not so sure.

ANITA: Aaron, don't you think that we're rushing things too much?

AARON: Maybe.

ANITA: I'm not ready to meet your parents yet.

AARON: You getting cold feet?

ANITA: It's been fun but…it's a lot to take on.

AARON: What d'you mean?

ANITA: My mum…your parents…

AARON: You trying to dump me?

ANITA: No… I'm not ready for the whole family thing. Makes it so heavy.

AARON: Thing is, I'm only happy when I'm with you these days. Weird.

They kiss.

What we gonna do about your mum?

ANITA sighs and looks away.

ANITA: Probably never even seen a naked man before apart from my dad and my brother when he was a kid.

AARON: And such a fit black man…

ANITA: Shut up.

AARON: I thought she'd never stop screaming.

ANITA: The neighbours were in a state. They thought someone had been murdered.

AARON and ANITA remember the scene and both cringe. Then they look at each other and start to laugh.

AARON: She thought I was there to burgle her daughter.

ANITA: After a bit of rape and pillage.

AARON: 'Cos I'm obviously a crack addict.

ANITA: Poor Ma.

AARON: Yeah but she obviously thought I was a criminal. That was her immediate impulse.

ANITA: I think it was all too much for her. She still hasn't got her head around the idea of sex before marriage.

AARON: Asian women her age…they all have their preconceptions about us.

ANITA: What d'you know about Asian women her age?

AARON: They tarnish us all with the same brush.

ANITA: What all of them?

AARON: She wanted to call the police!

ANITA: She found a naked man hiding in a wardrobe. It was a shock!

AARON: Are you defending her?

ANITA: You don't know my mum, you can't make assumptions.

AARON: I bet she's the sort who holds tight onto her hand bag whenever she sees a black person in the vicinity.

ANITA: What the fuck're you talking about?

AARON: Okay…sorry. It's just…there's a lot of bad blood between Asians and black people. You gotta admit it.

ANITA: So, what you saying?

AARON: Uganda?

ANITA: You think Idi Amin had a point?

AARON: No, but there's a history there.

ANITA: That's because the colonialists used Asian indentured labour in those countries and set the Asians up. My parents were born in Tanzania – they were part of that whole set-up. Same in Kenya and Uganda… Do I have to give you a history lesson now?

AARON: Woah…okay…since we're on the subject… How many Asian shops you see around here with black staff working in them?

ANITA: They run the shops themselves – family affairs. They never employ anyone.

AARON: And they throw the change at us. Don't want to touch us.

ANITA: What?

AARON: Your dad ever employ a black man in his company?

ANITA: Why d'you have to make this so personal?

AARON: All I'm saying is between your community and my community, things have been difficult. Black people think Asians have got rich whilst they're still on the bottom rung.

ANITA: That's just the politics of envy. Asians suffer too from racism. I get it all the bloody time. Especially with this 'war on terror'.

AARON: Yeah but you're not Muslim.

ANITA: Tell that to the white kids that scream 'Muslim cunt' or 'Osama's whore' at me out the car window.

AARON: You gotta remember, we were enslaved. We were packed into ships, we were shackled and dehumanised. We lost our language, our families, our names. It goes on. Even to this day. If you're a young black man in this country, you're more likely to go to prison than you are to university. Fact.

ANITA: So, you're more oppressed than I am? Is that it?

AARON: Just accept it.

ANITA: Okay, I accept that the experience of slavery is a much bigger thing that the Brits ruling over India. I accept that in effect the African slave experience is one of genocide.

AARON: Thank you.

ANITA: But I don't accept that my mum thinks you're all criminals.

AARON: I saw the look in your mum's eyes. She was terrified when she saw me. Like I'd just exploded from the jungle.

Half man, half animal. She was disgusted at the thought of her precious daughter coupling with a black man.

ANITA is furious.

ANITA: That's your fantasy Aaron.

AARON: My fantasy?!

ANITA: Yeah – maybe you get off on this idea that you scare little Asian women with your 'animal' persona. But I can assure you, my mum's not like that. Don't start passing judgments on her before you've met her properly.

ANITA goes back to her paperwork and ignores AARON. AARON watches her disturbed.

SCENE 3

RAJ is sat in his favourite armchair again. Only this time, his hand is bandaged up.

He still manages to graze from a bowl of nuts though.

RAJ: (*Calls out.*) *Bowdi!* Can I have a refill please?

ANITA enters carrying a freshly filled bowl of nuts.

ANITA: Hi Uncle.

RAJ: Ahhh…Anita…my favourite niece…

ANITA: Your only niece Uncle Raj.

Uncle RAJ reaches up to hug ANITA but she resists.

RAJ: Three days I've been here and now finally you come to visit.

ANITA: How's your hand?

RAJ: Burnt. Electric shock you know.

ANITA: I heard. The phone attacked you. How awful.

RAJ: Switch the TV off will you? You and I need to talk.

RAJ peers at the remote control nervously. ANITA looks annoyed picks up the remote and flicks the TV off.

I am your father's brother, so it falls to me to be the head of the household in this situation.

ANITA: What situation?

RAJ: The one that you find yourself in now.

ANITA looks bored.

Listen to your uncle. That's all I ask. You can do that – *nah?* Indulge an old man.

ANITA: Uncle…you are so indulged it's a criminal offence.

RAJ: I know it's hard at your age to find a suitable boy. Most of the good ones have been snapped up.

ANITA: I'm not that old Uncle!

RAJ: In the marriage market you are. You have met a boy – yes?

ANITA is silent

Your mother found him naked in your wardrobe.

ANITA: You heard about that?

RAJ: Every last detail, down to the boy's birthmark. I know you are a mature woman of the world so there is no need to be coy with me. You are educated, intelligent, you have a decent profession, a place of your own, you are a modern woman.

ANITA: But?

RAJ: You mustn't turn your back on everything you were brought up to believe in. Anita, do you want to marry this man?

ANITA: No.

RAJ: That is good because he is black.

ANITA opens her mouth to say something but RAJ ploughs on.

I am not prejudiced. Some of my best friends are black fellows.

ANITA: I can't believe you just said that…

RAJ: By all means, have fun, sow your oats and beans but when it comes to marriage… (*He tuts and shakes his head with a grave foreboding.*) it won't do. It's all very well falling in love but at the end of the day, can the relationship survive the pressures of modern life?

ANITA: It's really not that serious. You don't need to…

RAJ: What I am saying to you, I said to my own daughters. When you are looking for a life partner, you must look at the family, the culture, the education and of course the genes. American men for example – too bigheaded and rather stupid. English men – okay for a bit – nice humour and a good sense of self-irony but after three years of marriage, they can't help themselves.

ANITA: What?

RAJ: They start pinching other women's bottoms. I've seen it. Office parties and the English married men do this bottom pinching. (*He does a pincer action with his fingers.*) Australian men are coarse and the accent is horrible. And then the time difference means that you would never be able to speak to your mother on the phone and you would be on the other side of the world. Plane tickets are far too expensive. Plus, the big problem with white people is they wrinkle quickly. By the age of fifty, they are old, blotchy skin, flaky hair and of course the usual drink problem.

ANITA: Uncle Raj…

RAJ: Listen, listen…Don't even think of marrying a Muslim because you'd have to convert and they can just say 'Talak, talak, talak' and you're divorced. Black men are incapable of being faithful. Whilst you're married to them, they'll be having babies with all your best friends behind your back.

ANITA gets up in protest and exclaims.

(*Firm.*) Sit down and listen. You owe it to your mother and your dear departed father. Your behaviour is disgraceful and if you won't listen to your poor mother, you *will* listen to me.

ANITA looks horrified and exits swiftly. RAJ continues his speech unaware ANITA has left the room.

As for Indians. Well, the Gujeratis are like the Jews – money-minded, business-orientated, before you know it, you'd be running a newsagents never seeing the light of day. All your money goes into a family pot and you'll live in one of those extended families. Like communists they are. Punjabis – nice looking but the only culture they have is agriculture. Sikhs – all that greasy long hair… you'd be expected to wash your husband's hair… South Indians are very pure-blooded and their literacy rate is 100 per cent but they're too dark, almost black. Marawaris are uncouth and chew beetle nut all the time and Sri Lankans are troublemakers. (*We hear a toilet flush offstage.*) Always fighting. Look at the state of Sri Lanka today? No, the best thing for you is to marry a nice Bengali boy. Educated, same family background, same religion and let's face it, we are the most cultured people in the nation. Look at Tagore, look at Sen – two Nobel Prize winners from India and both of them Bengalis.

ANITA enters. RAJ turns to look at her.

I can see you think I am talking sense.

RAJ sits back in his armchair.

ANITA: You were always jealous of my dad weren't you? Better looking, more successful, more likeable, beautiful wife.

RAJ splutters his protests.

We've all known how you had the hots for Ma.

RAJ: Don't be disgusting!

ANITA: Three days after dad was cremated, you'd already started your moves on her.

RAJ: That's not true!

ANITA: Think I'm stupid? Both me and Pradeep saw you, in the kitchen, hugging her while she cried.

RAJ: I was comforting your mother.

ANITA: Yeah right. Rubbing your hands up and down her back. Trying to get into her sari.

RAJ: I am ashamed to be related to such a…such a… filthy-minded creature as you. You have no respect for your elders, for your mother, the memory of your father who quite frankly in my opinion spoilt you…

ANITA: You done Unc?

RAJ: You may be hell-bent on dragging your family name through the mud but I will put a stop to your indecent relationship.

RAJ gets up and walks out.

ANITA smirks.

SCENE 4

LETICIA is sat in a café on her own, waiting. She has obviously made an effort with her appearance. From time to time she looks around her anxiously. NEVILLE saunters in, still wearing his bus driver's uniform.

NEVILLE: Why you drag me here woman?

LETICIA: You still in your work uniform!

NEVILLE: What you expect? I come straight from work.

LETICIA: You have plenty time to go home and change.

LETICIA hurriedly brushes NEVILLE down.

NEVILLE: What's going on? What is dis place?

She sniffs him.

Stop sniffin' me like dat!

LETICIA: You been on the drink again?

NEVILLE: Me jus' have a quick one with de boys.

LETICIA: A quick one or three Neville? Lord have mercy! You stink like a rum shack…

LETICIA pulls out some perfume from her bag and starts spraying NEVILLE.

NEVILLE: Stop it! Me don't wan to smell like a gyal.

LETICIA: Better dan smellin' like a cheap bar.

NEVILLE: What's got into you? Why you phone me and march me down to this café?

LETICIA: Sit down. They be here any moment now.

NEVILLE: Who? Letty, why you actin' so strange.

NEVILLE sits down reluctantly.

LETICIA: I get me a call, from the girl's mudder.

NEVILLE: What girl?

LETICIA: Aaron's Indian Princess.

NEVILLE: Her mudder call you?

LETICIA: Say she want to have a lickle talk with us.

NEVILLE: What for?

LETICIA: I don't know! But she sound like she very serious.

NEVILLE: What Aaron him say?

LETICIA: I didn't tell him.

NEVILLE: Rass…why you agree to this meeting Letty? It not good. Sneaking behind our son's back.

LETICIA: I know. Me not feel good 'bout it neither. But me worry. You hear about what these Indian like. What if they want to warn us?

NEVILLE: You think them vex about Aaron?

LETICIA: I read about it in the papers. Honour killings dem call it.

NEVILLE starts to giggle.

This serious Neville! They could slice our son up. Cut him up into lickle pieces because him offend dem by seeing an Indian gyal.

NEVILLE giggles even more.

LETICIA sucks her teeth at NEVILLE and gives him the bad eye.

Everything a joke to you. You never grow up.

NEVILLE: And you have an over-active imagination.

LETICIA: This could be a serious ting man!

NEVILLE collects himself.

NEVILLE: It pretty clear to me why dem want to meet us.

LETICIA: Do tell.

NEVILLE: Remember las' time we have to meet parent of one of Aaron's woman friends? When was dat?

LETICIA thinks and the penny drops.

LETICIA: Michelle's parents? You think this Anita gyal is…? (*LETICIA gasps.*)

NEVILLE: We gonna have us anudder sweet lickle granchile and Aaron is a baby father again.

LETICIA: (*Angry.*) Why you never talk to your son family plannin'?

NEVILLE: Why is it my job? You're the nurse.

LETICIA: And you is the father. You should be doing all that man-to-man talk with him.

NEVILLE looks cross.

RAJ and CHITRA enter. A big moment as NEVILLE and CHITRA recognise each other immediately.

CHITRA: Mr Jackson!

NEVILLE: Mrs Mukherjee?

LETICIA and RAJ look from one to the other.

LETICIA: You know each other?

NEVILLE: One of my regular passengers!

RAJ appraises NEVILLE's uniform snootily.

RAJ: You're a bus driver Mr Jackson?

NEVILLE: Thirty years now.

CHITRA: I take his bus to work every morning.

NEVILLE: For ten year now. Regular as clockwork.

LETICIA looks put out by the obvious familiarity between the two.

So, it your daughter my son is hanging around with?

CHITRA: Well, it certainly looks that way Mr Jackson.

NEVILLE turns to LETICIA.

NEVILLE: Her daughter is a senior lawyer. If Aaron play him card right and dem hitch up, him never have no worry for cyash.

NEVILLE giggles again at his own joke but no one else does.

RAJ: My name is Raj Mukherjee. I am Anita's Uncle. Why don't we all sit down?

RAJ pulls out a chair for LETICIA and CHITRA. They all sit down.

LETICIA: I order some tea already.

RAJ: How thoughtful of you.

LETICIA: Shall I be mother?

CHITRA nods. LETICIA pours tea for everyone. Awkward silence.

So, Mrs Mukherjee, why you call this emergency meeting?

CHITRA is about to speak when RAJ interjects.

RAJ: We wanted to address the issue of Anita and erm…your son.

LETICIA: Aaron. Milk everyone?

CHITRA: Yes please.

RAJ: Just a drop. So, we wanted to know, how do you feel about the two of them together?

LETICIA: We haven't had the pleasure of meeting Anita yet. You meet my son?

CHITRA: No…erm…yes.

LETICIA: Him a smart boy. Got himself a good job.

CHITRA: (*To NEVILLE.*) Do you think it's serious?

NEVILLE: Yes…*Evening News…*

LETICIA: No, she mean de relationship.

NEVILLE: Oh…yeah mon. Never see my boy acting so love-sick before. Hey Letty, you notice how him keeping singin' round the house?

LETICIA: And giving me sweet embraces every two minute.

NEVILLE leans forward and winks at CHITRA.

NEVILLE: Young love Mrs Mukherjee – you remember dat feeling – eh?

CHITRA can't help but smile.

LETICIA: Stop your foolishness Neville. So, Mrs Mukherjee, you have other granchile?

CHITRA: Erm…no?

LETICIA: So this be your first?

CHITRA is confused.

NEVILLE: We have three now. India nearly thirteen.

CHITRA: (*Horrified.*) You think Anita's…pregnant?

RAJ sighs.

LETICIA: I thought that's why you call us?

CHITRA: No!

RAJ: To be honest Mr and Mrs Jackson, our family are not very happy. We don't think it's a very healthy situation…

NEVILLE: Who this man Mrs Mukherjee? Him speak for you?

RAJ: I am her husband's brother.

NEVILLE: But you not the father?

RAJ: In our community, the men look after all their female relatives.

NEVILLE: In our community we let the woman speak out. We don't wrap 'em up in blanket and hide dem from de world.

LETICIA: (*Warning.*) Neville…

CHITRA: Mr Jackson, My brother-in-law is simply helping me out here. I'm confused – about my daughter – having this relationship with your son…

NEVILLE: What's to be confused about? A man and a woman take a shine to each other. It the way of the world from back in the day. You want to stop it?

RAJ: It would not be seen in a very good light in our community if Anita took up with an African man.

NEVILLE: We from Port Antonio in Jamaica. From what Aaron tell me, you de African ones.

RAJ: I was born in Tanzania yes – but we're Indian.

NEVILLE: You speak Swahili?

RAJ: Yes.

NEVILLE: Den you African.

CHITRA: Listen Mr Jackson, Mrs Jackson. An Asian girl and a Jamaican boy…even in this day and age, it's difficult.

LETICIA: What you saying? My son not good enough for your dawta?

CHITRA: No, It's not like that.

LETICIA: Then tell me how it is.

RAJ: What we're trying to say is that we won't allow this relationship to continue. We want an end to it before it goes any further. Never in the history of our family has anyone married out.

LETICIA: What I tell you Neville. These people. Dem proud, dem haughty, dem tink they better dan us.

CHITRA: No, no…you've taken this the wrong way.

NEVILLE: What other way is there to take?

NEVILLE stands up, affronted.

You people tink you so special. You stand back while we work hard, take de licks. You never stick your neck out for us.

RAJ stands up to NEVILLE.

RAJ: Mr Jackson, no offence but you're a bus driver. We come from a family of lawyers, accountants, engineers… Anita is precious to us. We don't want to see her making the wrong decision in life.

NEVILLE: Seem to me Mister, you are a Rass Claat! Seem to me mister, you are a good for nutten, snob. We have a long history of suffrin' an' we can smell something *bad* coming from you.

CHITRA is upset.

RAJ: We have a long history of suffering too. We were ruled by the British for two hundred years.

NEVILLE: But we were put in chains, dehumanised, families ripped apart, sold, beaten, murdered…

RAJ: When I first came to this country, I worked on a building site, I shifted bricks, I drove a tractor even though I was a fully qualified teacher.

NEVILLE: White people spat at us on the street, called us names, refused to give us jobs, housing…

RAJ: I worked myself up from nothing. So don't talk to me about suffering.

NEVILLE: Then you should know Mr Mukherjee. Suffering should teach a man to be humble. It should show you we are all the same. To show respec' for all fellow humans.

RAJ: I agree, but there are some things that are plain wrong.

NEVILLE: Why you have such a problem with my buoy? You ever meet him? Why the idea of having him in your family make you so fearful?

LETICIA: Aaron a good boy. Him look after us, him look after him dawta. Always there for him chile.

RAJ: He has a daughter?

This is news to CHITRA.

LETICIA: A beautiful accident – when Aaron just twenty.

NEVILLE: Some accident meant to be.

CHITRA: Oh…

RAJ: It's even more inappropriate then isn't it? We are descended from the most ancient civilisations of the Indus Valley, going back to the beginning of time.

NEVILLE: And the first human remains are found in Africa, where we are descended from.

CHITRA: Please, stop it, both of you.

NEVILLE: Five hundred year ago, we enslaved and we treated worse dan any human…

RAJ: You have to ask yourself why you allowed yourselves to become slaves. In India we fought back. We were never slaves.

CHITRA hangs her head in shame. NEVILLE has had enough and decks RAJ who collapses to the floor with a bloody nose. LETICIA and CHITRA scream.

Did you see that? Chitra?! You see how aggressive these people are? You see?

NEVILLE: All dat suffrin' Mr Mukherjee, mean we don't take no shit from no one anymore.

RAJ cowers.

And you Mrs Mukherjee, me ashame of you. Me tink we understand each other, but now you show your true colour. If you tink we can stop dem young people from loving each other, you is living in a fantasy land. I tell you before and I tell you again. You gotta let your dawta live her own life. Come Letty.

CHITRA is upset.

CHITRA: Neville – wait!

LETICIA: Neville?

LETICIA looks at NEVILLE and CHITRA accusingly. It is obvious that they know each other quite well. LETICIA gets up with dignity and they are about to leave when CHITRA starts to have a panic attack.

LETICIA stares at CHITRA.

Mrs Mukherjee – are you okay?

CHITRA: Can't breathe…

CHITRA collapses in the chair, gasping for breath looking frightened. NEVILLE steps over RAJ who is still holding his bloodied nose and whining.

NEVILLE: She having a panic attack.

LETICIA: She look like you used to look when me mudder
come visit.

RAJ: My nose! My nose!

LETICIA looks down at RAJ in disgust.

LETICIA: Stop your whining man.(*To CHITRA.*) Breathe slowly
Mrs Mukherjee. Deep, slow breaths. Neville, go find a
paper bag.

RAJ: Call an ambulance, you've broken my nose!

*NEVILLE ignores RAJ, steps over him again and exits in search of a
bag whilst LETICIA tries to comfort CHITRA.*

Isn't someone going to help me?

*LETICIA sucks her teeth, hauls RAJ up into a sitting position and
has a good look at his nose.*

LETICIA: I may not be a doctor, lawyer or accountant like
the rest of your family Mr Mukherjee…but I have been a
nurse for thirty years and a senior sister for the last ten.

RAJ: Is it broken?

LETICIA: No, jus' a bit…hold on…

*LETICIA grabs hold of RAJ's nose and expertly pulls it hard. It makes
a loud crunching noise. RAJ screams like a baby.*

There, it back in place again.

RAJ whimpers.

*NEVILLE rushes back in with a paper bag, this time kicking RAJ on
the floor as he goes. He hands the bag to LETICIA. She places the
bag over CHITRA's face.*

Now, jus' breathe in deeply Mrs Mukherjee, Fill the bag
with air slowly, then breathe it all back in again.

CHITRA does as she is told and slowly starts to calm down.

NEVILLE: Feeling a lickle better already?

CHITRA nods gratefully. RAJ nurses his bloodied nose and whimpers.

SCENE 5

We are back in ANITA's bedroom. ANITA is pacing angrily whilst AARON is sat on the edge of the bed, looking guilty.

ANITA: When were you gonna tell me?

AARON: I was waiting for the right moment.

ANITA: You lied to me!

AARON: No…not lied exactly…

ANITA: Then what?

AARON looks uncomfortable.

You have a thirteen year old daughter. A teenager?

AARON: Yes.

ANITA: And I had to find this fact out through my mother?

AARON: Why did your mum call a meeting behind our backs?

ANITA: Because that's exactly the sort of thing she'd do.

AARON: My dad is furious with your family.

ANITA: Don't change the subject. You ashamed of your daughter? Is that it? What kind of a father are you that you can totally deny her existence? Does she even know about me?

AARON: She knows about you and I'm a good dad. I love India.

ANITA looks at AARON amazed.

That's her name. It was her mum – Michelle's idea. I see India almost every day. She comes and stays some week ends. She's clever, sassy, talks a lot and she's very much part of my life.

ANITA: Whilst I'm just a temporary fixture.

AARON: No. You're different. I didn't tell you because… I didn't want to frighten you off. I didn't want you to think I was… I was scared you might get the wrong impression.

ANITA: What? That you're a part-time father? An irresponsible, womanising, commitment-phobe?

AARON: That's not fair. I was only twenty…

ANITA: You lied to me.

AARON: Forgive me Anita.

ANITA: How can I?

AARON: Please.

ANITA: How can I trust you? How do I know you haven't got more secrets? More babies dotted around the place. That's what you black men do isn't it? Spread your seed and leave the women to deal with the shit job of bringing up a kid on their own.

AARON: Don't you dare…

ANITA: Admit it. It doesn't look good does it?

AARON: Look, maybe if you met India…

ANITA: It's too late for that.

AARON: She's a child Anita.

ANITA: Exactly! We talked about having children. We had a conversation about names and all the while…you already had a child… I can't believe you did that to me.

AARON: It's because you're special.

ANITA: You're so fucked up.

AARON: I was going to tell you!

ANITA: How can we carry on after this?

AARON: This is exactly what I thought would happen. You'd find out I had a kid and then dump me.

ANITA: You think I'm that shallow?

AARON: So you're not dumping me?

ANITA: I don't trust you.

AARON: So what are you saying?

ANITA: What about India's mum? She another one of your discarded blondes?

AARON: We were both kids.

ANITA: And that makes it alright?

AARON: Neither of us was ready to settle down.

ANITA: But she ended up holding the baby while you roamed free.

AARON: She's married now and I was always there for India.

ANITA: On a part-time basis.

AARON: You don't know, you can't pass judgment on me.

ANITA: Don't you understand what an enormous breach of trust this is? To find out through a third party that you have a secret child?

AARON hangs his head.

I was so angry with my mum for organising that meeting. Such an interfering bloody-minded thing to do. I'm glad

your dad broke my uncle's nose. I'm sorry that they insulted your parents. But just as I was having a go at them both, they told me you were a dad! Imagine! I couldn't even hide the fact that I didn't know. Felt so fucking stupid. And my uncle looked so smug.

AARON: He sounds like a total bastard.

ANITA: It takes one to know one.

AARON: Anita. I love you. I didn't expect that to happen. And the more I fell for you, the more scared I got that I'd lose you.

ANITA: It's so easy for you isn't it?

AARON: What d'you mean?

ANITA: Love. You use the word with such confidence.

AARON: What do you want me to say?

ANITA: Nothing.

Beat.

AARON: You only went out with me to shock your mum. Thought that if you brought home a black boyfriend, you could get at her.

ANITA is silent.

So now your family are on your back, you're using India as an excuse to get out of the relationship. I've served my purpose. You can go off and have a nice lickle arranged marriage – eh?

ANITA: Just get out will you.

AARON: Anita…

AARON tries to touch ANITA but she flinches.

ANITA: You heard me.

AARON hesitates.

I said – get out.

AARON exits.

SCENE 6

CHITRA is texting again on her phone. MONTU enters. He looks around surreptitiously

MONTU: That bastard brother of mine gone?

CHITRA looks at MONTU guiltily and nods.

CHITRA: I sent him home.

MONTU: Good!

CHITRA: His nose is bent.

MONTU: Ha! Serves the bugger right. Quite a left hook that Mr Jackson had – eh?

CHITRA: I felt a bit sorry for Raj.

MONTU: Don't. He always was an idiot. Now that I'm gone, there's no one there to slap the stupid boy down.

CHITRA: He's hardly a boy.

MONTU: Age has made him worse. Talks utter bollocks.

CHITRA: Don't swear.

MONTU: Glad you saw the light of day though and sent him packing.

CHITRA: He thought he was helping…

MONTU: But he made things worse. Why did you have to turn to him?

CHITRA: I shouldn't have.

MONTU: You should have listened to me! You called me, I came.

CHITRA: But you're dead Montu. How can you help me? Our daughter is slipping away, confused, seeing a 'Black Casanova'.

MONTU: How do you know what he's like? Have you made the effort to even get to know him?

CHITRA shrugs.

CHITRA: He is not right for our daughter. (*Wails.*) He lives in a council house!

MONTU: You are an insufferable snob! Anyway, you like his father… You meet him for lunch breaks. I've seen you. Sneaking off to the park, flirting.

CHITRA: (*Horrified.*) You've seen me?

MONTU: I'm not saying you're doing anything wrong but…

CHITRA: Mr Jackson is a decent hard-working man.

MONTU: So is his son.

CHITRA: No. He is not the right culture. I want a-son-in-law I can relate to. Grandchildren who don't laugh at my accent…

MONTU: You think an Asian boy would be any better?

CHITRA: Yes!

MONTU: But Chitra, you can't force Anita to love someone she doesn't.

CHITRA slumps in her chair.

MONTU approaches her and sits close.

Do you remember when we first met?

CHITRA: How could I forget?

MONTU: You were wearing a yellow sari and your hair was held back with a silver pin.

CHITRA: I was wearing red and my hair was loose.

MONTU: No, I remember…

CHITRA: I was forced to wear red by my mother, even though the colour never suited me.

MONTU: Is that right?

CHITRA: (*Warm.*) And you were wearing a suit which was two sizes too big for you. So skinny!

MONTU: I was wearing a dhoti. I never wore a suit.

CHITRA: You've forgotten.

MONTU: Your brother led you into the room and you were shy. You wouldn't even look at me.

CHITRA: I looked straight at you and I served you tea.

MONTU: No, it was coffee. I never drank tea in those days. Coffee was the drink of intellectuals.

CHITRA: And then you spilt the tea all over your trousers.

MONTU: My hands were shaking. And it was coffee.

CHITRA: You were nervous. I was terrified.

MONTU: No. I wasn't nervous. I just thought you were the most beautiful creature I'd ever seen.

CHITRA: Really?

MONTU: Truly.

CHITRA: You never said…

MONTU: I didn't want you to get big-headed.

CHITRA: When I looked up, and I saw your eyes, I knew we would be together.

MONTU: You smiled at me.

CHITRA: I didn't.

MONTU: Your mother scolded you for being so brazen.

CHITRA laughs.

CHITRA: Yes, I remember her telling me off.

MONTU: For me, it was like fireworks had been lit under me.

CHITRA: For me too. But I had seen you before. I'd begged my brother to introduce us.

MONTU: I had begged your brother too.

CHITRA: I didn't know that!

MONTU: Didn't you?

CHITRA: You never told me.

MONTU: At first your brother said I was too black for his beautiful fair-skinned sister.

CHITRA: (*Laughs.*) He had such a colour prejudice but he eventually realised what a good man you were.

MONTU: Chitra, what we had was special. You, Raj and all the collective auntijis of Greater Manchester cannot stop Anita from choosing her lover, whatever the colour of his skin.

SCENE 7

AARON is sat at the bar drinking. He is looking maudlin. FRAN approaches and sits down next to him.

FRAN: You wanted to see me.

AARON: Yeah.

FRAN: Anita'll kill me if she knew I were here.

AARON: She won't talk to me.

FRAN: You fucked up. Still, three months, Aaron…you lasted a lot longer than most of her men, I'll give you that.

AARON holds his head in his hands. FRAN looks surprised.

God, you're not upset are you?

AARON: Yes! I am!

FRAN: You mean you actually feel something for her?

AARON: Yes.

FRAN: Bloody hell.

AARON: You are such a cynic.

FRAN: Am I gonna have to sit here, while you cry into your beer and ask me how to get back into Anita's knickers?

AARON: Yeah.

FRAN: Oh joy. 'Least buy me a drink.

AARON: What you having?

FRAN: Vodka lime.

AARON motions at the (imaginary) barman.

AARON: Don't know if she'll ever forgive me.

FRAN: Now you're being pathetic.

AARON: Must come to you more often, especially when I'm feeling low. Then you can kick me some more.

FRAN: Any time babes.

AARON: How do you know when you've found the 'one'?

FRAN: You asking me?

AARON: Yeah.

FRAN: I dunno.

AARON: You've never felt it?

FRAN: I guess…once…a long time ago. How do you know?

AARON: Wanna be with them all the time, to tell them everything, love everything about them – the way they move, the way they think, their take on life, their humour, the way they laugh, every inch of their body…and you just wanna lose yourself inside them.

FRAN: That's lust.

AARON: No it isn't. I didn't even mention sex.

FRAN: But you meant it.

AARON: Obviously you have to want their bodies but I've yearned for women before now without actually *wanting* them. If you know what I mean.

FRAN: Don't tell me you're in love with Anita?

AARON: I think I am. I think this is the one.

FRAN laughs.

FRAN: She only went out with you to get back at her mum.

AARON looks hurt.

AARON: Maybe to begin with but it grew… She makes me feel good, happy and loved. Never thought I'd get that.

FRAN: Now I've heard everything.

AARON: Alright then Ms Cynical 2008 – how about you?

FRAN: How about me?

AARON: You never gonna settle down?

FRAN: Nah… Can't imagine waking up to the same bloke every fucking morning. Kinda like to have babies though – one day.

AARON: If you need any super spunk, you know where to come.

FRAN: Ta Aaron. I'll keep you in mind.

AARON: Just remember, with me, you could get pregnant and have a good time.

FRAN: Are you offering to have sex with me?

AARON: All for the good of humanity.

FRAN: That'd go down well with Anita

AARON: (*Groans.*) Anita.

AARON holds his head in his hands.

FRAN: Saddo.

FRAN laughs.

AARON: Don't laugh at me, I love her. I can't bear it.

FRAN: Shouldn't have lied to her then should you? Twat.

AARON: You are such a hard-faced bitch – Fran.

FRAN: (*Snaps.*) Because I've had a lifetime of being lied to by arseholes like you. All lovey-dovey one minute – can't get enough of you then suddenly they turn.

AARON: So bitter and yet so beautiful…

FRAN: I learn from my lessons. You can't trust anyone – *especially* a man.

AARON looks at FRAN slightly frightened.

AARON: Why do you hate me so much?

FRAN is quiet.

You scared of losing Anita? Is that it? I'm not the same person I was even six months ago. People change Fran. You gotta allow for that.

FRAN: You won't ever change Aaron Jackson. You're still the same swaggering, arrogant heart-breaking bastard you were at school.

AARON: I'm telling you, I love Anita.

FRAN looks at AARON surprised.

SCENE 8

CHITRA and ANITA are sat on the bench together in the park. Both are looking away from each other and eating their sandwiches in silence.

ANITA: How's the medical centre?

CHITRA: Surgery full of sick people with the 'vomiting bug'.

ANITA: Lovely.

CHITRA: Sometimes, I think I should go into work wearing a surgical mask. So many germs floating around the place!

ANITA: You've always been healthy though Ma.

CHITRA: I was blessed with a good constitution. Unlike your father.

ANITA: (*Sighs.*) I miss him so much.

CHITRA steals a look at ANITA.

Uncle Raj gone?

CHITRA: Yes. Thank goodness.

ANITA: You know he has the hots for you?

CHITRA: The 'hots'?

ANITA: Y'know…

ANITA makes a gesture that mimics Uncle RAJ.

CHITRA: He's a menace. Making cow like eyes at me. Euch.

CHITRA makes cow-like eyes. They both giggle.

ANITA: So…you're not interested in him?

CHITRA looks at ANITA horrified.

It was a crazy idea to meet up with Aaron's parents and without telling us! Why did you do that Ma?

CHITRA shakes her head.

CHITRA: A mother's job is to look after her child, to the grave. I felt that I was protecting you. You didn't even know he had a child.

ANITA looks away.

Sometimes I sit on my own in the evenings in my house and the place echoes with memories. You and Pradeep running around the place, shouting and making mess… Montu chasing you…roaring like a Royal Bengal Tiger.

ANITA laughs at the memory.

I sit there in my big house, all on my own and I feel so…

ANITA shifts closer to CHITRA.

I wonder what happened to my little family – so scattered and distant. Pradeep away in another country building a new life, Montu gone and you… I miss you too. I know I have to let you all go – birds must fly the nest. I flew from mine – hardly saw my family after we came here. But still…

ANITA: I get lonely too. I'd like to meet a man who will love and cherish me. You and Baba always seemed to have the perfect marriage. I want that.

CHITRA looks surprised.

CHITRA: What about this black boy you're seeing?

ANITA: Say his name.

CHITRA: I can't pronounce it.

ANITA: Yes you can.

CHITRA: Iron.

ANITA: AARON!

CHITRA: Ayron.

ANITA: Close enough I guess.

CHITRA: Well?

ANITA: I think we're finished.

CHITRA remains silent.

If I had got together with him – which I won't – would you have disowned me? Cut me off?

CHITRA: Uncle Raj would have.

ANITA: I don't care about Uncle Raj. I'm asking about you.

CHITRA: If I disowned you, I would be the one who suffered.

ANITA: We were always friends Ma. We always had a good relationship – better than most my friends had with their mums. But lately, everytime I come and see you, all you do is harp on about getting married. I won't meet Bengali men that you set me up with. I won't do it.

CHITRA nods.

ANITA starts to cry.

CHITRA: Oh…baby…

ANITA can't speak. Instead she shows CHITRA her phone. It has a message on it. CHITRA reads it out.

CHITRA: 'Hey Anita. My name's India. I'm Aaron's daughter. Dying to meet you but A keeps us apart. When can we hook up? LOL. I. Xx' His daughter? Hmmm… At least she can write. Why didn't he tell you?

ANITA: He says he was going to but was waiting for the right moment.

CHITRA: He should have told you right from the beginning. That is dishonest. There is no future with a dishonest man.

ANITA nods and sobs. CHITRA gathers ANITA to her.

CHITRA looks at the text again.

(*Musing.*) Smart little girl though. Name is India?

ANITA looks at her mother slightly bemused.

Aren't you curious to meet her?

SCENE 9

It is night. The moon is out and ANITA is standing on her tiny balcony smoking a cigarette. She looks deep in thought. FRAN comes out and joins her.

FRAN: I was thinking of taking some time out from work. Haven't had a holiday in months.

ANITA: Yeah? I'll come with you. Somewhere hot, somewhere sun-soaked…

FRAN: You can't go on holiday. Too much on at work…

ANITA: I'll just farm some of the cases out.

FRAN: And you've got to sort this thing out with Aaron.

ANITA: There's nothing to sort out Fran. I've finished with him.

FRAN: But you love him don't you?

ANITA looks away.

It's not easy finding a mate. Sometimes I think, the world's so full of people and yet…so hard to see into the crowd and really find that one person.

ANITA: You've changed your tune!

FRAN: I think he really does care for you.

ANITA: Fran!

FRAN: I'm only saying this because you're my best mate and I want you to be happy.

ANITA: I gave it my best shot.

FRAN: We get so good at looking after ourselves – you know independent, clever, career women. We think we don't need a partner, a lover. We do it all on our own terms.

ANITA: We can! Who needs a bloke?

FRAN: We forget that relationships are all about give and take, making little compromises all the way.

ANITA: You said yourself that Aaron was a player.

FRAN: But people change.

ANITA: How do I know he's the right one? What if he turns around in ten' years time and…

FRAN: Don't throw it away before you've given it a chance.

FRAN holds ANITA, hugs her tight and then exits.

AARON enters and stands below. He watches her for some time, unseen in the dark.

Eventually, he steps out.

AARON: Anita?

ANITA is silent.

I'm sorry. Forgive me.

ANITA: Go away.

AARON: I didn't lie. Just didn't quite give you the whole picture.

ANITA: You're a babyfather!

AARON: She's a lovely kid. You'd get on. You don't need to be her mother. Just a friend.

ANITA: And if we don't get on? What if she hates me?

AARON: Why are you assuming she'll hate you?

ANITA: Please Aaron – let's just call it a day. I can't handle this. It's bad enough with you and me being different.

AARON: What d'you mean 'different'?

ANITA: Asians and Afro-Caribbeans don't have a great history of getting on. You said as much.

AARON: We can change it.

ANITA: Yeah right.

AARON: It shouldn't matter.

ANITA: But it does.

AARON: What matters is us.

ANITA: Leave me alone.

AARON: I can't. I love you. Never felt like this about anyone.

ANITA looks upset.

And I know you feel the same way.

ANITA: Go home.

AARON: We belong together.

ANITA: I can't trust you.

AARON: We all make mistakes.

ANITA: That's crap.

AARON: Please Anita. I love you. I want to wake up every morning next to you and come home at night to you. I want to read the Sunday papers with you and travel the world together.

ANITA: What about babies?

AARON: Yes! Babies with you!

ANITA is quiet.

AARON goes down on bended knee.

ANITA: What are you doing? Stop it! The neighbours can see!

AARON: Anita Mukherjee – will you marry me?

ANITA: No!

AARON: For better or worse?

ANITA: You're a liar.

AARON: I promise never to lie to you again.

ANITA: See? You're lying again.

AARON: Marry me and be my love forever.

ANITA: Aaron. We hardly know each other. Four months isn't…

AARON: It's long enough to know.

ANITA: No.

AARON: You mean 'yes'.

ANITA: Give it another year and then we'll see.

AARON: Just say yes.

ANITA: No.

AARON climbs up and joins her at the balcony. He takes her in his arms and kisses her.

AARON: Say yes.

ANITA: No.

They kiss again.

AARON: Say yes.

ANITA: It's too soon.

AARON: Okay. Let me move in then.

ANITA: I have to meet your daughter first. And your parents.

AARON: Okay.

ANITA: And then maybe in a year's time, if we're still speaking, you can move in.

AARON: You're too cautious.

ANITA: You know what us Asians are like. Cold, calculating, always practical.

They kiss again. This time it gets a bit steamy.

AARON: Marry me.

ANITA: No.

They end on another kiss.

SCENE 10

MONTU is pacing around the lounge. He looks very, very nervous. CHITRA is rushing around with bowls of nuts etc.

MONTU: Whatever you do, don't mention Uganda.

CHITRA: Ah Montu – they're from Jamaica.

MONTU: Okay, then don't mention Christopher Columbus…. East India, West India – got it all mixed up.

CHITRA: What are you talking about?

MONTU: Taboo subjects Chitra.

CHITRA: I will manage. Stop pacing! You're making me nervous.

MONTU: Get out the Appleton Rum. There should be some in the back of the drinks cabinet. Just make sure the father has an inexhaustible supply and he'll be happy.

CHITRA: Oh okay.

MONTU: And keep your eye on the mother. She is the important one. Make sure she is happy and never, ever make any detrimental comments about her son.

CHITRA: Now you're going too far! I am not a total imbecile.

MONTU wears an expression as if to say that this is debatable.

MONTU: And best not to mention the wardrobe incident.

CHITRA wags her finger at MONTU.

CHITRA: And As for you Montu. No funny games. Understand? How do I look?

MONTU: Beautiful. I always loved that sari. I bought that in Orissa. Remember? The Konarak Temple?

CHITRA: How could I forget?

The door bell rings.

MONTU: (*Excited.*) They're here ! They're here!

CHITRA: Calm down.

MONTU: Good luck.

CHITRA takes a deep breath as the door bell rings again and bustles out. MONTU sits down in his arm chair as CHITRA re-enters a few moments later with AARON and ANITA. (Throughout this scene, MONTU is wandering around, seen only by CHITRA but heard from time to time by NEVILLE.)

AARON: My parents and India will be here in a moment. They're just parking up.

ANITA: Ma, I should formally introduce you to Aaron.

CHITRA: No introductions are necessary – we've met before haven't we?

AARON laughs and shakes hands.

Sit down – except you Anita – go and fetch some dips from the kitchen. They're all laid out.

ANITA: Okay.

AARON goes to sit down in MONTU's lap, but CHITRA guides AARON to another chair.

MONTU: Woah!

ANITA leaves, looking anxiously over her shoulder as she goes.

CHITRA: This is more comfortable.

AARON sits down gingerly.

So young man, we finally meet.

MONTU: Nice-looking boy.

AARON: (*Nervous.*) Yes…

CHITRA: Why did you lie to my Anita about your daughter?

AARON: I didn't want her to get a bad impression of me.

CHITRA: And you thought dishonesty was the only way forward?

AARON laughs nervously.

MONTU: Bul-Bul, go easy on him.

CHITRA: Hmmm… And what about your intentions towards my daughter?

AARON: Honourable.

CHITRA: You're black.

MONTU: Bul-Bul!

AARON: Yes. Is that a problem?

CHITRA: Have you any idea how hard it's going to be for the two of you? Have you thought this through? People will give you a very hard time.

AARON: We don't care. We just want to be together.

CHITRA: Do you have a job?

AARON: Yes.

CHITRA: Will you be loyal to her? None of this hanky-panky behind her back?

AARON: No. I love Anita. I wouldn't do that to her.

CHITRA: If you do, then I will come round and give you two tight slaps.

CHITRA raises her hand in a threatening gesture. AARON cowers.

So you'd better behave yourself.

MONTU covers his face in exasperation and rocks back and forth.

The door bell rings.

ANITA: (*Off.*) I'll get it!

AARON looks relieved. CHITRA reaches over, AARON flinches but CHITRA simply squeezes his cheek hard but affectionately.

We hear the sound of the Jacksons arriving.

LETICIA: (*Offstage.*) You tek so long to park! Look how late we are!

NEVILLE: (*Offstage.*) If you didn't tek so long to get dressed. How many outfits you try on?

LETICIA: (*Offstage.*) You drivin' around for half an hour looking for a space. You terrible at parking anything smaller than a bus.

NEVILLE: (*Offstage.*) Doesn't help with your back street driving 'ooman.

AARON: They're be a bit stressed.

ANITA enters followed by LETICIA, NEVILLE and INDIA who are all dressed up for the occasion. MONTU stands up when he sees NEVILLE.

MONTU: Ahhhh…so this is the man you've been meeting behind my back?

CHITRA: Please, come in, sit down. Hello Mr and Mrs Jackson…welcome…

NEVILLE, LETICIA and CHITRA all greet each other.

LETICIA: Thank you for inviting us.

NEVILLE: Mrs Muckherjee, you are bloomin'.

CHITRA: (*Laughs.*) Mr Jackson.

LETICIA gives NEVILLE a cold look.

NEVILLE: I am looking forward to some nice home cooking Mrs Muckherjee. I'm starvin'.

INDIA: Gramps!

LETICIA: Honestly.

AARON: This is my daughter – India.

INDIA curtsies

INDIA: How d'you do Maam.

CHITRA laughs.

CHITRA: What a lovely name but you don't have to curtsy! I'm not the Queen. And you can call me Aunty Chitra.

INDIA: Oh, alright then.

CHITRA: So, India. What year at school are you in?

INDIA: Year 8. St Joseph's – a girls' school worse luck.

CHITRA: But girls' schools are good. I sent Anita to one and look how well she did!

INDIA: That's what my mum says – helps you concentrate on your school work.

CHITRA: What are your favourite subjects?

AARON: She's very good at drama. Wants to be an actress.

INDIA: Or a singer. He calls me a drama queen.

CHITRA: You should get along with Anita fine then.

ANITA: Drink anyone? India?

INDIA: Coke please.

NEVILLE: Erm…yeah…anything soft will do us.

CHITRA: I think I'll have a small sherry Anita.

LETICIA: Me too.

MONTU: He doesn't want a soft drink – he wants some rum!

CHITRA: And your father says there's some Appleton Rum in the drinks cabinet.

ANITA shoots her mother a warning look.

LETICIA: I thought your husband was…?

CHITRA: I always forget – still talk as if he's alive. Takes some getting used to.

NEVILLE: Rum sounds perfect. (*To ANITA.*) Straight, no ice please.

LEITICIA: Only one though.

AARON: C'mon India, let's give Anita a hand.

INDIA and AARON move off with ANITA to go and pour the drinks.

CHITRA: So… Mr Jackson… Mrs Jackson…

NEVILLE: Neville – please.

LETICIA: Leticia.

Awkward beat.

CHITRA: Neville, Leticia, this is quite a situation we find ourselves in isn't it?

NEVILLE: After the las' time we meet.

LETICIA: Your card was very much appreciated. Anita seems like a lovely girl. We had a nice chat earlier on.

NEVILLE: Deal with India's cheek with ease.

LETICIA: She's a very bright child…although she becoming a bit of a teenager now.

CHITRA: Horrible years for a parent. Anita went through a Goth phase. Painted her room black and only ever wore black clothes and bright red lipstick. So dismal. It was like living with someone in the Addams Family. My husband used to jump in fright every time he saw her. Such a depressing colour – black. She looked like a devil worshipser.

NEVILLE looks like he can't believe what CHITRA has just said. MONTU hangs his head.

NEVILLE: Me glad she grow out of that.

NEVILLE gives LETICIA a look.

MONTU: For God's sake woman! Change the subject! Don't use the word black!

LETICIA: This is a very nice place you have here Mrs Mukherjee.

CHITRA: Please – call me Chitra.

LETICIA nods and makes a hash of saying CHITRA's name.

LETICIA: Cheeta.

LETICIA peers at CHITRA's shrine.

It's a bit big for me now. Four bedrooms upstairs. I wander around it like a ghost now. Babies have flown the nest, husband gone, just me knocking around on my own. Waiting for grandchildren now.

NEVILLE: Now, now, don't jump the gun. Plenty more youth left in you Chitra. Still a good-lookin' woman. Don't want to rush into grannyhood yet.

NEVILLE winks at CHITRA. LETICIA looks put out as CHITRA giggles coyly.

MONTU does a double take and looks at NEVILLE closely.

MONTU: That man's a rascal!

ANITA, AARON and INDIA return with the drinks.

NEVILLE: At last!

Drinks are handed around.

AARON: Dad…

ANITA: Leticia…

LETICIA: Thanks darlin'.

NEVILLE stands up and raises his glass.

NEVILLE: Here's to…new friends.

Everyone says 'Cheers' and downs their drink.

Awkward silence.

INDIA: So, Anita, you gonna take my dad away from me?

AARON: (*Warning.*) India…

INDIA: It's just that all of his other girlfriends get really clingy and snooty about me being around.

AARON: That's enough cheek…

INDIA: You can't compete with me so don't even try.

MONTU stands and peers at INDIA.

MONTU: Anita's got her work cut out for her with this one.

ANITA: Thanks for the warning. I'm not really the clingy type though.

INDIA: Just as well.

AARON: (*To INDIA.*) Where d'you get off talking to Anita like that?

INDIA: I'm just laying down the law.

LETICIA: Enough of your cheek chile.

INDIA: Mum said that once you get a girlfriend – like a proper one – you won't have so much time for me.

AARON: I don't care what your mum said.

CHITRA: Children today – eh? They know their minds.

INDIA nudges AARON.

INDIA: Go on Dad.

AARON clears his throat and stands up. He exchanges a look with ANITA.

AARON: Everyone, now that we're all here together…erm…I wanted to…erm…I know I'm no angel…and I've got a bit of a reputation…

LETICIA: You telling me boy…

NEVILLE: Hush 'ooman.

LETICIA: I'm just agreeing with him!

INDIA: Gran! Let Dad speak.

AARON: Erm…

MONTU: Come on Aaron…breath. Nice and slowly. You can do it.

AARON looks very nervous.

AARON: I've finally found someone I want to be with for the rest of my life.

AARON and ANITA hold hands.

I asked Anita to marry me and she said 'no' but then she changed her mind and said 'yes'.

Silence.

NEVILLE: Congratulations. I'm delighted.

MONTU: Congratulations.

NEVILLE leaps up and shakes hands with AARON, hugs and kisses ANITA. INDIA hugs them too.

CHITRA, and LETICIA are silent and stunned.

AARON focuses on CHITRA and kneels down at her feet.

CHITRA: Oh god, don't propose to me!

AARON: Mrs Muckherjee, I now we didn't exactly get off on the right foot but I am deeply in love with your daughter. Do we have your – blessing?

Beat.

CHITRA: What kind of a wedding are you planning to have?

ANITA looks relieved and hugs her mother. CHITRA squeezes AARON's cheeks. LETICIA remains seated. MONTU looks over at LETICIA.

NEVILLE: Let's have a drink.

LETICIA looks wildly around the room.

LETICIA: So tell us, what kind of a wedding *are* you planning to have?

AARON: Registry office, non-denominational.

LETICIA: No church?

AARON: No Mam.

INDIA: Ace. So I don't have to dress up in a poncey, flouncey bridesmaid's dress?

ANITA: We'll put you in a sari instead.

INDIA: Double ace.

CHITRA: But you have to have the ceremony in the Temple?

ANITA: No Ma. Registry office then a big party after.

CHITRA: But the Gods?

ANITA: No gods.

CHITRA: *Hai Ram.*

AARON: But we're planning to go to India for our honeymoon.

INDIA: Can I come too?!

AARON: No.

NEVILLE: Let's have a drink!

LETICIA: Neville…

NEVILLE: Hush up woman. We need to celebrate.

> *NEVILLE tries to exit but LETICIA pulls him down. MONTU exits.*

LETICIA: They have to be married in a church otherwise it can't be sanctified.

AARON: Mum…

CHITRA: (*To ANITA.*) I'll call Meera aunty tomorrow and she can get an appointment with the temple priest and we have to talk to an astrologer to make sure the stars are auspicious.

LETICIA: Stars?

CHITRA: Heavenly constellations.

LETICIA: Neville, what is this woman talking about?

NEVILLE: Stop interfering Letty.

ANITA: Mum, we're not doing any of that.

LETICIA: You have to get married in a church. Aaron?

AARON: No Mum.

CHITRA: Anita, your father and I walked round the fire seven times, you must do the same.

LETICIA: Fire? Stars? Aaron? You can't get married like this!

NEVILLE: Letty why you two so miserable? This a happy day.

LETICIA: Family is important.

CHITRA: I agree.

MONTU re-enters carrying a bottle of rum and two glasses. He pours.

MONTU: This isn't about you though is it?

NEVILLE: This isn't about you though is it?

MONTU sips from his glass. NEVILLE notices the glass of rum by his side, looks delighted and swigs it back. As he places the glass down, MONTU refills it.

LETICIA: (*Scolds NEVILLE.*) Where you get that drink from?

MONTU: Leave him alone, you nag.

CHITRA: Nag? Don't be so rude!

ANITA: Mum!

LETICIA: I beg your pardon?

CHITRA: Sorry, I didn't mean you, I meant…

LETICIA: She call me a nag!

CHITRA: No, I …

LETICIA stands up affronted. NEVILLE swigs back the second drink. MONTU is standing behind LETICIA so it looks as if CHITRA is talking to her.

LETICIA: You people, all de same.

AARON: Mum, don't start…

LETICIA: She insult me las' time, she do it again.

CHITRA: (*Turns to MONTU.*) Look what you've done now? Couldn't keep your trap shut, could you?

ANITA: Ma! What's got into you?

CHITRA: I'm talking to your father. He's standing right behind…oh…

ANITA: Dad has been dead for three years Ma, he is not here.

INDIA: (*Giggles.*) She's mad.

AARON: Shut up India.

> *MONTU sits down, pours some more drinks. NEVILLE is delighted that his glass keeps refilling itself.*

NEVILLE: Like magic! (*To no one in particular.*) Thank you.

MONTU: My pleasure.

> *NEVILLE looks a little bemused and turns to see where the voice came from.*

Your wife's a little over-exciteable isn't she?

NEVILLE: Yeah Mon. Always she know her mind.

LETICIA: Who you talking to Neville? How much of that you drink? As far as I is concerned Mrs Mukherjee, unless they are married in a church, it does not count.

CHITRA: Why do you always assume that your way is the best?

AARON: Stop it, both of you!

NEVILLE: Times change Letty.

LETICIA: (*Jabbing her finger at NEVILLE.*) You keep outa dis. Me always have to drag you to Church. You is a godless man.

NEVILLE: Don't point your finger at me ooman.

LETICIA: As far as I is concerned Mrs Muckherjee, I don't want my son to have anything to do with you.

NEVILLE: (*Dissappointed.*) Letty.

CHITRA: The feeling is mutual Mrs Jackson.

AARON: (*Looks to his father.*) Dad? Stop them!

NEVILLE shrugs and takes another drink.

MONTU: You're behaving like a couple of witches.

CHITRA: (*To MONTU.*) Witch?

LETICIA: How dare you!

CHITRA: Please, you keep taking my words the wrong way.

ANITA: Mum, take it back.

LETICIA: That's because you people don't talk straight. You have too many Gods. It confuse your mind. There is only one true Lord.

MONTU: Watch is Chitra, she's a Bible basher!

AARON: Mum – don't…

LETICIA: Dese tings matta son. Religion don't mix.

AARON: But I'm not religious.

LETICIA: They're idol worshippers! Full of mumbo-jumbo superstitions. How can you live like that?

NEVILLE: Now you go too far Letty.

MONTU: Take her out Bul-Bul.

CHITRA: You insult my culture, my religion. So small-minded!

LETICIA: I know. I know what you want. Try and change my son into some kind of a hippy. Next ting I know, he be banging a drum and shakin' a tambourine in the street.

MONTU dances around and shakes a tambourine.

MONTU: Hare Krishna, Hare Krishna…

CHITRA: If he does, then it's better than standing in a cold church listening to some idiot vicar talking out of his backside.

ANITA: Oh god Ma…

AARON can't help but laugh along with NEVILLE. All the women look at the men – aghast. INDIA giggles.

LETICIA: What you find so funny?

INDIA: Aunty Chitra just described our Vicar.

LETICIA: You may find it funny but I don't. I want nuthin' to do with this wedding.

CHITRA: Good because you are so full of insecurities –

LETICIA: I am not. You're the one with the superiority complex. You de definition of a racist.

ANITA and AARON have both had enough.

AARON: Stop it! Both of you! This is ridiculous.

ANITA: We are going to get married whether you like it or not.

AARON: With or without your blessing. If you can't handle the situation then you don't have to be there for us.

NEVILLE: My blessing is given happily.

INDIA: And mine.

NEVILLE stands and raises his glass.

NEVILLE: (*A little drunk.*) I is delighted. May you both have a long and happy life together.

NEVILLE turns and catches a glimpse of MONTU clutching a glass of rum. MONTU raises his glass to NEVILLE and smiles.

NEVILLE looks surprised and confused but raises his glass to MONTU nevertheless.

INDIA hugs ANITA.

CHITRA and LETICIA eye each other up warily and reluctantly raise their glasses. It is a tense celebration.

SCENE 11

We are back in the Mukherjee lounge. It is a few months later. CHITRA enters with INDIA in tow, INDIA is in her school uniform.

INDIA: Thought I'd drop in on my way back from school. Starving. You got any food Aunty Chitra? Only didn't get a chance to have any lunch. Gran's at work and Mum's doing some conference out of town. Won't be back 'til late…

CHITRA: Of course I have food.

INDIA: You know those little pastry thingies you do, with peas and stuff inside…

CHITRA: Samosas!

INDIA: Can I help?

CHITRA: Of course. Go and get an apron from the kitchen.

INDIA: Dad phoned and said he'd seen an elephant in a temple and that Anita had gone mad and bought up half a sari shop.

CHITRA: So they're having a good time?

INDIA: Sounded pretty ecstatic. Can't believe they didn't take me though.

CHITRA: And what would you have done with all that hugging and kissing going on?

INDIA: Hugging and kissing?

CHITRA: That's what they do on honeymoons. Anita and Aaron will be spending most of their time staring into each others eyes saying 'I love you'.

INDIA: Eeeuuu…

CHITRA: Very boring for a third party.

INDIA: Just as well I didn't go.

CHITRA: You can come here as often as you like and sometimes, maybe, we can go and do some shopping together.

INDIA: Wicked. And can we watch some of those all-singing all-dancing flicks together?

CHITRA: (*Amused.*) You like Bollywood?

INDIA: I love Bollywood.

CHITRA: In that case, why don't you go and have a look in the TV room? I have hundreds of DVDs. You can pick one and we can watch one now.

INDIA: (*Very happy.*) Yes!

INDIA exits.

MONTU appears.

MONTU: So Bul-Bul – you have a new friend.

CHITRA: I think she's rather taken by me.

MONTU: You happy now?

CHITRA looks longingly at MONTU.

You got what you wanted. Our baby is married off to a good man.

CHITRA: I hope so. It was just a shame we couldn't have a proper wedding.

MONTU: At least she wore a sari.

CHITRA: We should count our blessings.

MONTU: And you didn't have to step foot inside a church or wear a hat.

CHITRA: Thank God. What about you Montu? What happens to you?

MONTU: I go back.

CHITRA: Do you have to?

MONTU: I'm afraid so. I've already overstayed my limit.

CHITRA: I wish I could come with you.

MONTU: You have to stay. You are going to grow to a very old age and have grandchildren. Pradeep is about to meet someone.

CHITRA: Is he?

MONTU: And you will always be loved.

CHITRA: But without you…

MONTU: I will still be there in your dreams, in the moments just before you awake. When our first grandchild is born, I will be there and when you see something beautiful, I will see it too and share that moment.

CHITRA: Will I ever know you again?

MONTU leans forward and kisses CHITRA gently on the mouth.

MONTU: Remember how when we married, the Priest said we were married for seven lifetimes?

CHITRA: I never knew which lifetime we were supposed to be on.

MONTU: The next one will be our third so – yes, we will know each other again.

CHITRA: I hope so because no other man will ever reach me the way you did.

The light begins to change on MONTU.

Please don't go – not yet…there's so much I haven't asked you…

MONTU: I must. They are calling me.

CHITRA: Montu! Please stay…

MONTU: I can't. You must move on. Live your life and be happy Bul-Bul.

MONTU starts to fade in the bright, bleached light.

Never forget how much I loved you.

CHITRA: I will always love you.

CHITRA cries as MONTU disappears. She sits motionless for a moment and tries to collect herself. INDIA reappears carrying an armful of DVDs.

INDIA: I don't know which one to choose…these all look great.

INDIA clocks CHITRA's mood and joins her on the sofa.

Are you okay?

CHITRA nods.

You missing your husband?

CHITRA nods.

Don't be sad.

INDIA hugs CHITRA.

CHITRA: Now – Let's go and make some pastry thingys shall we? Yes, yes…come on. Come to the kitchen and I'll show

you how they're made. Then after, we can watch one of these films together. Okay?

INDIA: It was so funny at school today…Bog Roll tripped up. That's what we call our history teacher 'cos he goes on and on and on…anyway, he tripped up and bashed his big toe on the floor and he'd broken it.…so they had to call an ambulance…and then when they turned up they caught a man at the bottom of the school field flashing… y'know…exposing himself…so the ambulance drivers started chasing this man round the school, with their siren going eew aww…eee awww…and I was having Art and we all looked out of the window and all we could see was this man, with his – y'know – hanging out, waggling away as he ran. (*She Laughs.*) they caught him and the police came and arrested him and we reckon he's Jemma Clark – she's the bully in the year above – we reckon he's her uncle!

Lights fade, lingering on the gods in CHITRA's shrine.

End.